Creative Discoveries in Watermedia

WATER'S EDGE
29"×40" (74cm×102cm)
Watercolor, acrylic, ink and Berol prismacolor
pencils on BFK Rives printmaking paper
Collection of Kumiko and Joseph Dews

Creative
Discoveries in
Watermedia

Pat Dews

NORTH LIGHT BOOKS
CINCINNATI, OHIO

About the Author

Pat Dews, an award-winning artist, is an elected member of both the American and National Watercolor Societies. She works experimentally using aquamedia on paper and canvas. Some of her recent successes include the American Watercolor Society's High Winds Medal (1995) and the Silver Medal of Honor (1993) awarded by the New Jersey Water Color Society.

Pat paints the very essence of nature with rocks and water a recurring theme. Collage is often integrated in her work, and she is a signature member of the National Collage Society.

Pat's paintings are included in *Splash 1* (1991); *Splash 2: Watercolor Breakthroughs* (1993); *Splash 4: the Splendor of Light* (1996); and *Creative Collage Techniques*, Nita Leland and Virginia Lee Williams (North Light Books, 1994). Her work also appears in *Sources of Inspiration, Watercolor '89*, an American Artist Publication and the article "Trial and Error Painting, Watercolor Magic" in *The Artist's Magazine*. She is on the staff of The Lighthouse Gallery and School of Art in Tequesta, Florida, and conducts workshops nationally.

Pat is a full member of the New Jersey Water Color Society, the Garden State Watercolor Society and the National Association of Women Artists. She is represented by the Long Beach Island Art Studios and Gallery, Long Beach Island, New Jersey; and Frame of Mind, Holmdel, New Jersey and Rumson, New Jersey.

Pat, with her husband, Joe, lives and works in Florida during the winter and on the East End of Long Island in the summer.

Creative Discoveries in Watermedia. Copyright © 1998 by Pat Dews. Manufactured in China. All rights reserved. No part of this book may be reproduced in any form or by any electronic or mechanical means including information storage and retrieval systems without permission in writing from the publisher, except by a reviewer, who may quote brief passages in a review. Published by North Light Books, an imprint of F&W Publications, Inc., 1507 Dana Avenue, Cincinnati, Ohio 45207. (800) 289-0963. First edition.

Other fine North Light Books are available from your local bookstore, art supply store or direct from the publisher.

02 01 5 4 3

Library of Congress Cataloging-in-Publication Data

Dews, Pat.
 Creative discoveries in watermedia / by Pat Dews
 p. cm.
 Includes index.
 ISBN 0-89134-830-1 (hardcover : alk. paper)
 1. Watercolor painting—Technique. 2. Artists' materials. I. Title.
ND2420.D52 1998
751.42′2—dc21 98-9463
 CIP

Edited by Pam Seyring and Glenn L. Marcum
Production edited by Amanda Magoto
Designed by Angela Lennert Wilcox

Dedicated to those who make life worthwhile:
My parents, Ethel and Ed Kane; my husband, Joe; my sons, Joe and Jim; and their wives, Kumi and Allison.

BEACH PEBBLES
12″×16″
(30cm×41cm)
Watercolor and collage
on 140-lb. (300 g/m²)
cold-pressed watercolor
paper
Private collection

The aim of art is to represent not the outward appearance of things, but their inward significance.—Aristotle

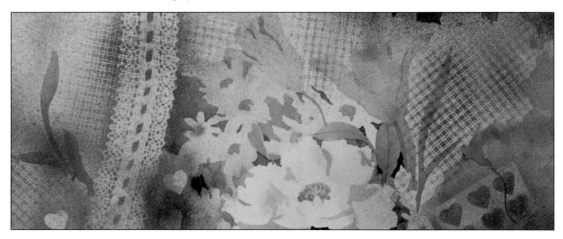

HEARTS AND
FLOWERS
8¼″×20¼″
(21cm×51cm)
Watercolor, acrylic and
ink on BFK Rives
printmaking paper
Collection of Julie
Lizewski

Acknowledgements
I thank God for the talents He so generously gave me. I thank my wonderful husband, Joe, for his constant love and support and for most of the great photos in this book. I truly could not have done it without him. My thanks to Rachel Wolf, who asked me to write this book and then had faith I could do it; my editors Pam Seyring and Glenn Marcum for their experience and guidance in the writing of this book; production editor Amanda Magoto; designer Angela Wilcox; and everyone on the art department and North Light staff who helped bring this book so beautifully to the printed page.

I also thank my contributing artists—Dorothy Skeados Ganek, Dean Mitchell, Robert Vickery, Robert Sakson and Pat Denman—for so kindly sharing their wonderful work; Linda Laska and Arches for generously supplying me with my favorite papers; my good friends and artists Roberta Carter Clark, Shirley Cunneff, Eleanor Dreskin, Dorothy Ganek, Sandra Thurber Kunz and the late Pat Lafferty, who helped shape me as the person and painter I am today; the late Nicholas Realle and my sister, Diane Howland, a gifted quilter, who lent an eye and gave me comfort food when I needed it the most.

Table of Contents

CHAPTER ONE

Getting Started

Cultivating Your Attitude and Ideas

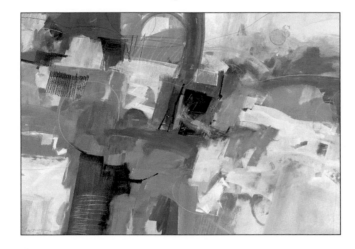

CHAPTER TWO

A Broad Vocabulary of Techniques

CHAPTER THREE

One Start, Three Finishes

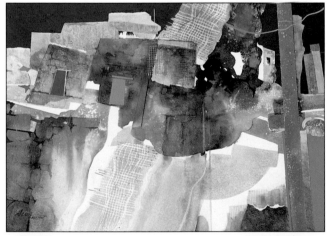

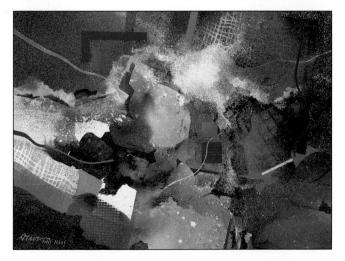

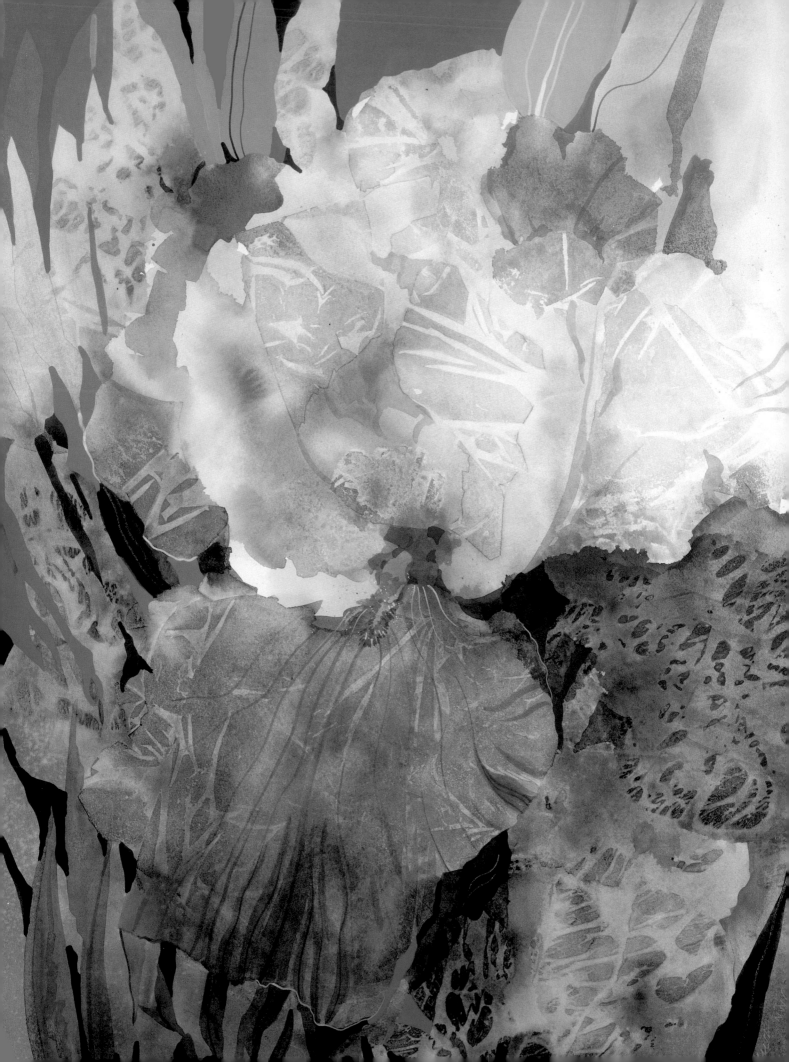

Introduction

Techniques are methods of rendering artistic works, procedures used to translate your ideas into finished paintings. Being familiar with a variety of techniques makes it easier to represent your ideas. This book includes many techniques for starting and finishing successful paintings, as well as how to generate excitement, create new surfaces, correct mistakes, crop creatively and much more.

Follow along as accomplished artists share their thought processes with you and show you exciting ways to see, how they get their ideas, and how they turn those ideas into successful works of art. If you have the desire to work hard, you can do it too! If you have a positive attitude and think you can, you can! Each artist is unique, so draw from all that makes you unique.

Be Your Best You

Growing up, I was the one who loved to do product maps at school (remember the projects where you glued cotton to the state that produced cotton?); little did I know I was doing my first collages. I was drawn in by the matchbook covers that said "Draw Me," and I did draw them. I religiously watched Jon Gnagy on television, following along with his book and TV program step by step. I took art courses in high school and college but never majored in art because I didn't think I'd be good enough. I didn't have a portfolio. I didn't have confidence. I didn't know that art was what I needed to do.

After graduating from the Fashion Institute of Technology in New York City, I worked in fashion buying for two months and knew it wasn't for me. I went to work for an advertising department, then talked my way into the art department, where I did layouts and mechanicals. The techniques I learned at that job stayed with me in my later work, and I also met my husband, Joe, there. Imagine if I had majored in art or worked somewhere else! Every choice makes you who you are and the artist you become. Don't try to become someone else; try to be your best you.

After leaving advertising to raise a family, I attended an art exhibit with my husband. I said, "I could do that." Joe later surprised me with a set of oil paints, and I started taking oil painting classes. I also took classes from Ferdinand Petrie, A.W.S. (American Watercolor Society). He was a good painter working in a realistic style, so I worked realistically as well. I painted what I knew: still lifes on my kitchen table, sand dunes, seascapes and barns. I copied what I saw while learning to use the medium and was happy when I got a close facsimile.

I continued taking classes, and one day I fell in love with a certain way of working and never painted the same way again. The late Nicholas Realle, A.N.A. (Associate of the National Academy), A.W.S., used poured paint, razor blades, sponges and a magic formula for separating his watercolor paint. He said he didn't feel he was as good at realism as the "big boys," so he was determined to find out what he did best. Once I saw his techniques, I knew I wanted to do them, too; I was hooked. I think the type of art you do chooses you rather than you choosing it; it's a matter of what you have an affinity for.

Pure Color and Design

After working with Realle, I remembered when I worked in advertising I went to an art exhibit of a fellow artist. Every painting was abstract, and I asked, "Do you paint anything real?" She said as an artist her work was more real than real, that she was interested in pure color and design. I didn't know at the time what she meant, but I was starting to get it and was so excited. I became a sponge; I read art books, attended exhibitions, joined groups, sold work at fairs and entered juried shows to gauge my work.

Just Do It!

I remember doing my first abstract seascape, pouring blues and greens over my paper. I threw oil into the paint and watched it separate. I was painting in the kitchen, and when I poured the white paint into the mixture to form foam, it poured all over the floor. You can't be creative and worry about a mess, your clothes, your floor or not having a place to work. Clean your floor each time, paint outside or at the house of a friend. Just do it!

First comes desire, then comes the attempt. If you've always wanted to paint but were afraid, this book's for you. My methods enable you to plunge in and get started.

Nothing's wasted. When all else fails, paintings are stored in collage boxes and used later to create new works, correct mistakes, plan finishes and learn design.

Creative discoveries are there, waiting to happen. They come when you least expect them. Working gives you confidence. By doing painting after painting, you'll find ways of working that are yours; get ready for your breakthroughs by letting this book help you see the possibilities.

IT'S THE JOURNEY

Painting is what I do and who I am. For me, the best part is the journey. When I'm painting, I get lost in the world I'm creating, and life is good. If I get a really good painting out of it, that's icing on the cake.

◀ IRIS ESSENCE
21½″ × 29½″ (54.6cm × 74.9cm)
Watercolor and acrylic on printmaking paper
Collection of Kathleen M. Hanes

Materials and Supplies

Paints

Paints

I use transparent watercolor, inks and acrylics interchangeably. I begin most of my paintings with transparent watercolor and ink and then switch to acrylic to finish. I do this because watercolor and inks are so immediate, and I want to get started. I finish with acrylic because I like the contrast of the opaque colors against the transparent colors and because I need to cover and change areas.

Acrylics

If you're just starting to gather materials and want to limit the financial outlay or if you just want to try some techniques, you could buy just acrylics. Acrylics are versatile, and you can work from transparent to opaque. Acrylics don't lift as easily as watercolor after they're dry. They're insoluble, and you can't use a stencil lifting technique. I prefer Liquitex acrylics, but I often buy brands on sale. Since I layer and overpaint extensively, using one specific brand isn't as critical as with other mediums. The colors listed here are Liquitex unless otherwise noted.

 ACRA Violet

 Alizarin Crimson

 Brilliant Blue

 Burnt Sienna

 Cadmium Orange

 Cadmium Red Light

 Cadmium Red Deep (a real favorite)

 Cerulean Blue

 Cobalt Blue

 Dioxazine Purple

 Hooker's Green Hue Permanent

 Mars Black

 Payne's Gray

 Permanent Green Light

 Phthalocyanine Blue (a real favorite)

 Raw Sienna

 Sap Green Permanent

 Titanium White

 Ultramarine Blue

 Vivid Lime Green

 Yellow Orange Azo (Shiva; a real favorite)

 Iridescent Bronze (Shiva)

 Iridescent Copper (a real favorite)

 Interference Blue

 Interference Red

 Light Blue Violet

 Turquoise Blue (Rembrandt)

 Quinacridone Crimson

 Quinacridone Gold

 Pearl

 Transparent Oxide (for glazing color change)

 Iridescents

Watercolor

It's important to use professional-grade watercolor paints. My brand of choice is Winsor & Newton Artists' Water Colour. I also use certain Holbein colors that are unique. I buy and have more colors than I list below even though I don't use them in every painting. I use a John Pike palette for watercolors. When I use Holbein colors, I squeeze them out onto a paper palette. I have the following watercolors on my palette:

Winsor & Newton Artists' Water Colours:

 Alizarin Crimson

 Winsor Red

 Rose Doré

 Cadmium Orange

 Cadmium Yellow

 New Gamboge

 Yellow Ochre

 Naples Yellow

 Raw Sienna

 Burnt Sienna

 Cerulean Blue

 Cobalt Blue

 Manganese Blue Hue

 Prussian Blue

 Cobalt Turquoise

 French Ultramarine Blue

 Permanent Sap Green

 Vandyke Brown

 Winsor Violet (Discontinued. Use Winsor Violet [Dioxazine] and Permanent Magenta.)

 Winsor Green (Blue Shade)

Additional Colors:

 Burnt Umber

 Sepia

 Neutral Tint

 Hooker's Green Dark (Discontinued. Use Quinacridone Gold and Winsor Blue [Green Shade].)

Holbein Artists' Watercolors:

 Opera

 Blue Gray

 Gray of Gray

 Violet Gray

Rembrandt Artists' Watercolours:

 Transparent Oxide Red

Dr. Ph. Martin's Hydrus Fine Art Watercolors:

 Sepia

 Payne's Gray

Inks

The inks I use most often are:

Dr. Ph. Martin's Tech Drawing Inks:

 Antelope

Indigo

Orange

Titanium White

FW Drawing Inks:

Antelope

Indigo

Turquoise

Olive Green

White

FW Acrylic Artists Inks:

Raw Sienna

White

Black India

Red Earth

Antelope Brown

Indigo

Flame Orange

Burnt Umber

Prussian Blue

Turquoise

Rowney Blue

Gouache and Casein

I also use a variety of colors of gouache and casein. Gouache is watercolor paint with white paint added to make it opaque. It's water soluble. You can make very flat opaque washes with it. Be careful, because it lifts if a wet brush touches it. I use it for value changes when I know that I'll not go back into a painting. You can use it to tone down areas of intense ink colors too. I also like to use it with cheesecloth texturing. It seems to hold and trap the texture of the cloth very well. I use my watercolor brushes with gouache.

Casein paints use a milk-based binder and are water soluble, but they dry rapidly and become impervious to moisture. Their adhesive qualities are excellent. I use my acrylic brushes with casein. Though naturally matte, casein can be brought to a satin sheen by buffing with a soft cloth.

Paper

My favorite papers are 130- and 140-lb. (280 and 300 g/m²) BFK Rives white printmaking paper and Arches 140- and 260-lb. (300 and 555 g/m²) cold-pressed watercolor paper. I also use 300- and 400-lb. (640 and 850 g/m²) Arches paper. I like and use Morilla and Lanaquarelle watercolor papers. I use Bainbridge Board No. 80 double thick, cold-pressed finish for poured paints—where there will be a lot of water—and for collage work.

Brushes

My favorite is a 2-inch (51mm) Robert Simmons Skyflow wash. I have a 3-inch (77mm) Skyflow wash for really large washes. Other brushes I use regularly are:

1-inch (25mm) Grumbacher Aquarelle 6142

no. 2 CJAS Happy Stroke Rigger

no. 7 Kalish Finest Kolinsky

no. 2 Kalish Finest Kolinsky

no. 4 CJAS Water Hawk

no. 12 round Winsor & Newton Series 101 Sceptre Gold (sable/synthetic blend)

no. 14 Prolene by Pro Arte Series 101 England

no. 14 Winsor & Newton Sable Style 665 Delta fan brush

foam sponge brushes in varying sizes

brights for acrylic and casein

Japanese hake brushes

an assortment of old, worn-out brushes

A good brush is so important; take care of your brushes so they last longer. I use Ivory Soap to clean my brushes after use. I massage the soap into the palm of my hand and make sure I get down into the ferrule of the brush. I dry them flat on a paper towel before storing them in my brush box. I never place brushes with their bristles down in water.

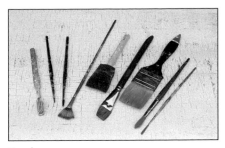

Brushes

Acrylic Products

Be sure to read all the labels for proper usage when using acrylic products. If you have questions, call the manufacturers; they really do have technicians and chemists to answer your questions. These products are insoluble, so wash your brushes with soap and water carefully after using. I use a separate set of watercolor brushes with these products; I use brushes specifically made for acrylic and my old, beat-up brushes.

Gesso

This thick compound—vehicle: acrylic polymer emulsion—is primarily used for a painting ground. I use it to prime surfaces such as canvas and Masonite, as a white to mix with acrylics for opaques with more body, as a white to block out areas on my paper that I want to eliminate, to get a new surface by covering areas I don't like, and for an impasto surface that can be textured.

Gloss Medium

I use gloss medium as an adhesive for my collage pieces. I am able to adhere sand and heavier papers without any fear of their coming loose. I use it to coat collage pieces when finished because of the adhesive quality, but I'm not overly fond of how shiny it is; I then coat them with matte medium or varnish. For the appearance of flowing water, I coat the area with the gloss medium and then proceed with white paint. This undercoating enables me to readily spritz alcohol to create water-like foam. I also use gloss medium between layers of acrylic paint to give more depth.

Matte Medium
Use matte medium to apply tissue and other light papers to collages. Matte medium can also be a final coat if you don't want a glossy surface.

Gel Medium
Gels are formulated with 100 percent acrylic polymer emulsion. Gel medium can be used for glazing, extending colors, altering sheen, changing body, increasing translucency, gluing collages and increasing film integrity.

Modeling Paste
I use modeling paste for thicker impasto areas. In collage work you can imbed materials as heavy as keys, pebbles or shells, and they will adhere.

Texture Gel and Natural Sand
Use texture gel and natural sand to produce a variety of textural and impasto effects.

Additional Materials

Toothbrush
I've tried many toothbrushes, but I like a used Oral-B the best. I use the toothbrush to spatter paint for texture and value change. I use it to spatter water for water spots, texture for backgrounds and texture for snow scenes. I also use it to scrub out paint and stencil lifts.

Single-Edge Razor Blades
I use single-edge blades to paint, scrape and cut.

Natural Sponges
I use an assortment of natural sponges to paint, scrub, texture, pick up extra paint and water from a too wet wash, and to wet my paper before stretching. They are softer than the synthetic sponges. I would be lost without a natural sponge.

Plastic Wrap
I use Saran Wrap brand plastic wrap because of its heavier weight. I use Saran Wrap for texture, paint transfers, lifting and applying paint.

Waxed Paper
I use waxed paper (CUT-RITE brand) for texture, paint transfers and depositing wax on my paper so paint will skip. I use the waxed paper crumpled and flat for different texturing.

Cheesecloth, Lace, Netting, Open-Weave Fabric, and Needlepoint and Hooked Rug Supports
I use all of these for paint transfer (applying paint to the surface and rolling with a brayer for texture), to spray paint through and to place in wet paint for texture. I also use some of these as collage elements.

Self-Adhesive Fiberglass Drywall Tape
This tape is great to paint through or press into wet paint to create texture. It can be cut and shaped and will stay in place while you paint, but it is easy to lift when the wash dries.

Bleach
I use diluted bleach to spritz for color and value change and to lift color. I use bleach sparingly and only with ventilation.

Salt
I love the texture salt makes, but I don't use it too often. The salt holds moisture, so be sure to rub it off.

Alcohol
I use rubbing alcohol for spritzing to make texture on BFK Rives paper and to lift paint for texture. It forms small circles, and it acts the way salt does—it disperses the paint. I also use it to scrub and lift dried acrylic paint from paintings and brushes.

Spray Bottle
I use an empty Vicks Chloraseptic bottle to spray. I have tried many spray bottles, and this one works best for me. Openings on others I have tried are too small or too large.

Mouth Atomizer
I use a mouth atomizer (used for spraying varnish) to spray paint for texture, value and color change and with stencils. I would be lost without it. The tool must be perpendicular to

Acrylic Products

the jar of paint you spray from, and the paint can't be too thick. You must wash the tool immediately after use so it doesn't get clogged. If you have a lung condition, do not use this—it takes a little effort. Use an airbrush instead. I use this for ease of travel and ease of cleaning, but it can't really do the job of an airbrush. And remember to blow out, not in.

The mouth atomizer I use is the best of all my discoveries. It is handmade and has made my work so much easier. For information, contact Greg White, 69 Sherburn Drive, Hamburg, New York 14075.

Toilet Tissue
I use toilet tissue to lift paint for color change and to dry too wet areas. Rolled across thick paint it makes texture. I prefer to use ScotTissue brand toilet tissue for these purposes.

Paper Towels
I use paper towels to wipe my brush as I paint, to roll into opaque paint to produce textures and for general cleanup. I use them to mask areas for spraying. I also paint and texture with them.

Grafix Frisket Film
I use this film to make masks for spraying.

Miskit Liquid Frisket
I use this Grumbacher product for masking areas that are to remain white or for preserving a color when glazing.

Construction Paper
I use this paper when I finish my paintings. I tape the paper to see

where I want a color and what color I want. After I see what I want, I remove the paper and paint the area.

Acetate

I use this to see what colors and any line work I want when I'm finishing a painting.

Facial Tissues

I use facial tissues to paint watercolor through (use something soluble so the tissue doesn't stick). When almost dry, lift the tissue to find great texture. Even with watercolor, don't leave facial tissue on too long, as it will stick.

Masking Tape

I use masking tape for straight edges, stencils, gently holding construction paper for design work, and holding masks for spraying.

Pickup

I use a pickup for lifting the dried frisket.

Brayer

I use this printmaking tool in several sizes. I use a brayer to press down papers for texturing and to actually paint with.

Palette Knife

I use a palette knife for lifting, mixing and spreading paint. I also use a knife to paint.

Rice Papers

I use these papers to either paint through or set into a wet wash (and later discard) for texturing. I also use these papers in my collages as the actual texture; the papers remain and become part of the painting.

Eraser

I use kneaded and Pink Pearl erasers.

Pencils

I use a regular no. 2 for sketching, and I use Berol Prismacolor pencils for line work and calligraphy.

Homosote Board

I use this board to stretch my papers on so I have a smooth, flat work surface. I have boards cut 1 inch (2.5cm)

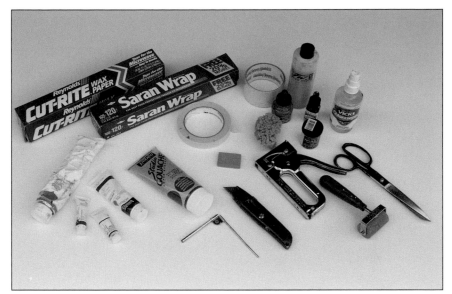

Additional Materials

larger on each side than my paper.

Staple Gun

I use an Arrow model JT21M gun. I find this one easiest to use for stretching my papers.

Screwdriver

I use a flat, thin screwdriver to remove staples from the Homosote board. I always push the screwdriver under the paper and the staple instead of between the paper and the staple to avoid marking the paper.

Scissors

I use scissors to cut my fabrics, tapes, waxed paper, Saran Wrap and anything I don't cut with my razor. I tear watercolor papers instead of cutting them if I want to change the size.

Paper Palette

I use a paper palette when I'm working in acrylic, casein or gouache. I sometimes use one for additional colors in watercolor or for fresh watercolor paints.

Gum Arabic Solution

I use this to increase the gloss or transparency of watercolors. I also use it to give more body to my colors.

Ruler

I use metal rulers of several sizes for tearing, cutting, measuring and as painting edges.

Winsor & Newton Oil Vehicle No. 1

I use this with watercolor. The oil makes the paint resist, creating a great texture.

Mineral Spirits

Watercolor painted over mineral spirits will resist and separate. This works well for sea-foam.

The Nita Leland Color Scheme Selector

This color wheel is invaluable for learning more about using color. Write to The Nita Leland Color Scheme Selector, P.O. Box 3137, Dayton, Ohio 45401-3137 for information.

Matcutter

I use a Logan Simplex Matcutter—it works great and is easy to use. Learning to cut mats is worthwhile; it's much less expensive to cut your own. Since my cropping technique causes me to work in so many sizes, it is far easier to make the mats than to figure out the different sizes and explain them to a framer.

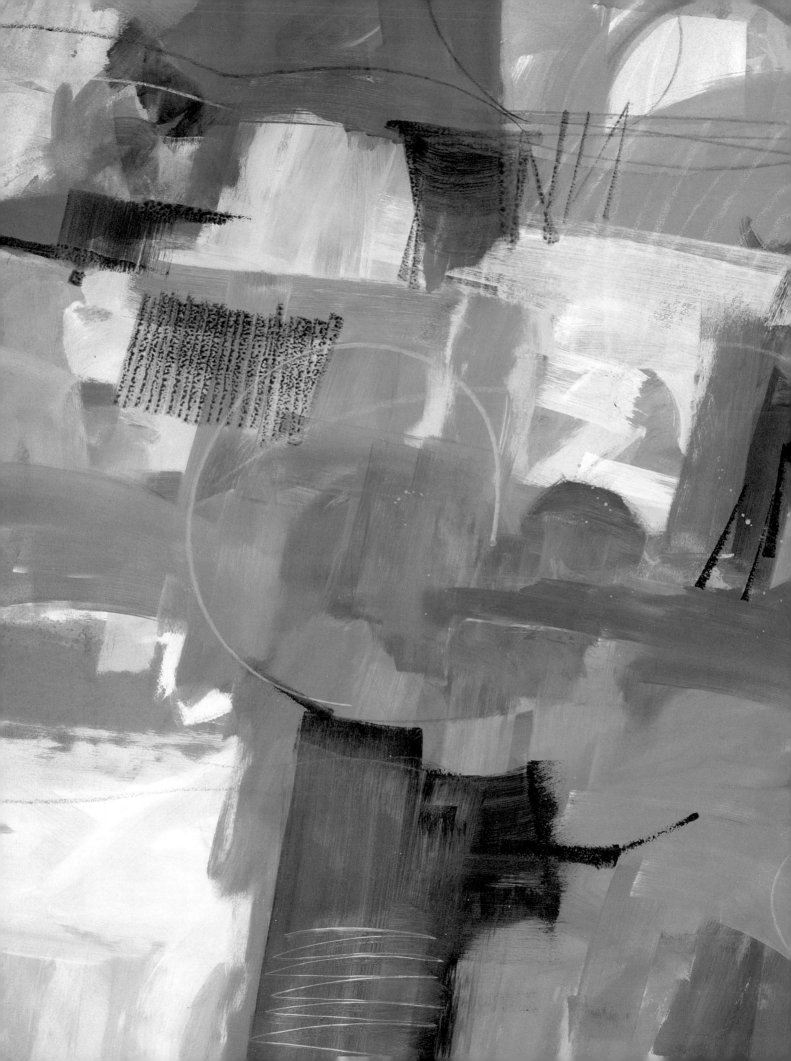

Getting Started

Cultivating Your Attitude and Ideas

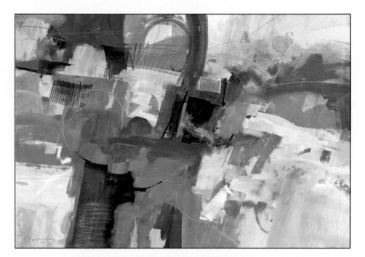

DREAMS OF A.W.S.
28½″×42″ (72cm×107cm)
Ink, acrylic and Caran D'Ache crayons

A good attitude gets you anywhere you want to go—in sports, school, your job, life and art. Attitude is a state of mind. Create a good state of mind and you create good art. Work hard, have good supplies and develop a good attitude; success will surely follow.

No-Fear Painting: Keeping a Winning Attitude

Knowing you need a good attitude is easy; having one is not always so easy. It's very intimidating to begin when you're facing a whole sheet of white paper. And when you do begin, you want not only a painting; you want a great painting. You have to psychologically prepare yourself. Remind yourself that it's only a piece of paper—it can be corrected—and that this is fun. Not many pursuits can be one's avocation as well as vocation. Try to watch a child paint and see if you can recapture the child in you. If you can develop an attitude of joy while working, it's no longer work. I'm a perfectionist and often change my paintings many times before I'm satisfied. I've written on the wall of my studio the following three thoughts: Stop worrying! Paint with joy! Enjoy life!

What Works for You?

Become aware of what works for you. Keep a journal, take walks, listen to music and learn to make lists. I need to listen to this as I write. When I listen to myself and take care of both my inner and outer self, my work is better.

Make Art Friends

Take art workshops with experienced artists and expand your horizons. You can learn from the instructor and from the students. Try to seek out friends with the same interests.

It's exciting and stimulating to share ideas in a group or a class. Painting is a lonely pursuit, and the support you get from fellow artists who are also friends can make a dif-

ference. When I moved to Florida, I missed my support system immensely. Artists need other artists for feedback; it's hard to be objective about one's own work. It's great to have an art friend get excited by a new painting you just finished, and it just feels good to share.

Paint for Yourself

Measure success by your last painting, not by someone else's. Remember that not every painting is a show painting and not every painting is a prizewinner. Some paintings aren't meant to be; they simply are. Prize-winning paintings in one show are rejected in other shows. Paint for yourself and not for shows. Paintings that please you are winners. Everyone wants to become recognized, and everyone dreams of winning awards in major shows, but you must try to think only about what you are painting and what you want to say. Put in time and effort on the paintings and have a strong desire to succeed. Chances are you will, with a little luck. There is a lot to be said for being in the right place at the right time—and for being ready for the luck. You can make your own luck!

Consider the Practical Side

Consider the practical, business side of art from the onset. Take good slides from the beginning and try to develop good business practices. Being good at your craft is not enough to succeed. People with less talent and strong planning have gotten farther than those with more talent but poor planning.

Getting There

Throughout this book I try to help you become a better painter. Painting takes time; it's a way of life. Be patient in your pursuit, and try not to be too hard on yourself. Someone once said, "A painting takes fifteen minutes and fifteen years." Take the time. Get started. Getting there—the journey—is the best part.

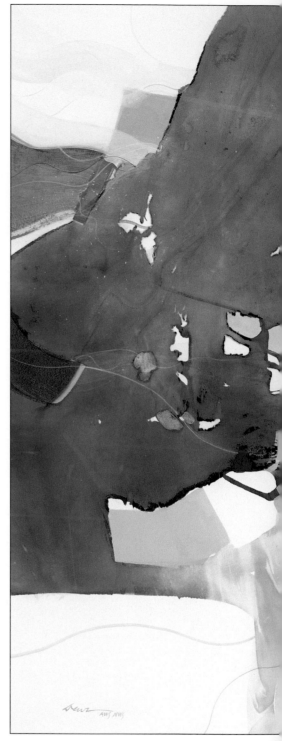

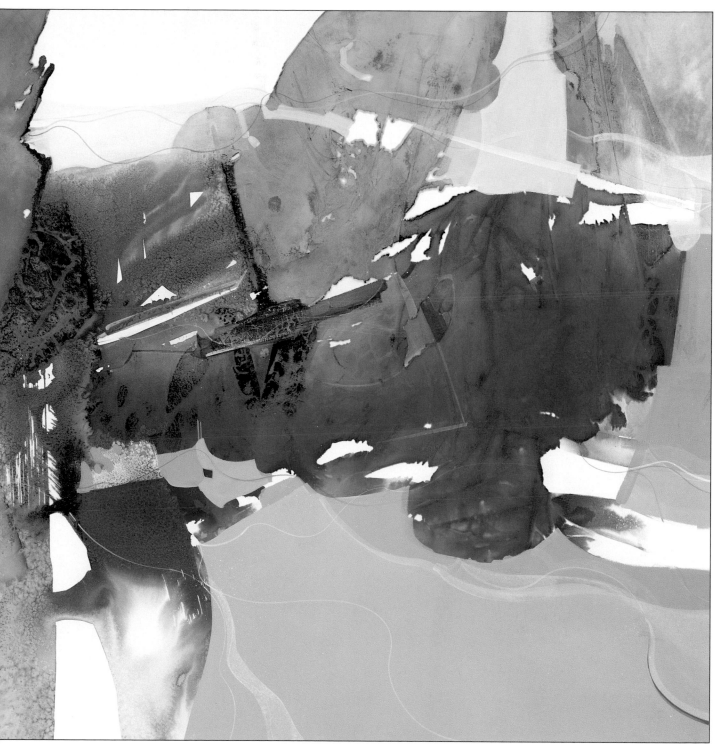

This is my favorite abstract. It has good color, texture and design and a cleanness and sureness that comes from not going back into the painting too much. One strives for this, but it is not always easy to achieve. With my quest for perfection I have a tendency to overdo. There is great beauty in pure, unadulterated washes of color. This was painted during a time of loss and was a breakthrough in the sense that it was a better painting than any I had previously done. It's almost as if it painted itself or God were directing the brush. For me, this painting became a new standard by which to gauge my work. I still think this is the best painting I've ever done.

SPINDRIFT II
28½″×41¾″ (72cm×106cm)
Watercolor, ink and acrylic
Awarded the Mario Cooper Award, 121st Exhibition,
American Watercolor Society

Abstract or Realistic: More Alike Than You Think

Beneath every good painting is a good abstract design or understructure. A good painting is a good painting, regardless of the genre. An Edgar Degas painting moves me as much as a Richard Diebenkorn. I find as much beauty in a realistic or impressionistic rendering of a person or scene as in the surface textures and color movement in an abstract piece.

See the Abstract Understructure

Degas was a master of design. Look at pictures of the figure paintings of this French Impressionist painter and try to imagine that you are looking at shapes and forms instead of people.

If you would take a piece of tracing paper, put patches of color in all the shapes and combine them with interesting texture and scumbling, you would have a great abstract painting. That's because the underlying structure is a good abstract design.

In still-life setups you work with abstract shapes. Look at the colors and shapes—not the subject matter—and you can get a better understanding of how colors and shapes relate and how abstract painters think. Look at a landscape and see the *shapes* of the houses, trees, streets and people. Look at size and shape relationships. An abstract painter looks at his world and extracts the essence.

Like a realistic painter, I consider my center of interest, shapes and forms, color, the movement of these shapes and colors through the painting, color values, variety and all the other elements of good design in creating a unified painting. I struggle with all these elements until I'm satisfied I have captured what I set out to say and nothing else I could add or subtract would make it a better painting.

An artist should be concerned with making the best painting possible. Paint what you want in any mediums you want. Use anything you need to create a good painting. Maxine Masterfield told me, in a workshop, to think only of the painting at hand and nothing else. She was right.

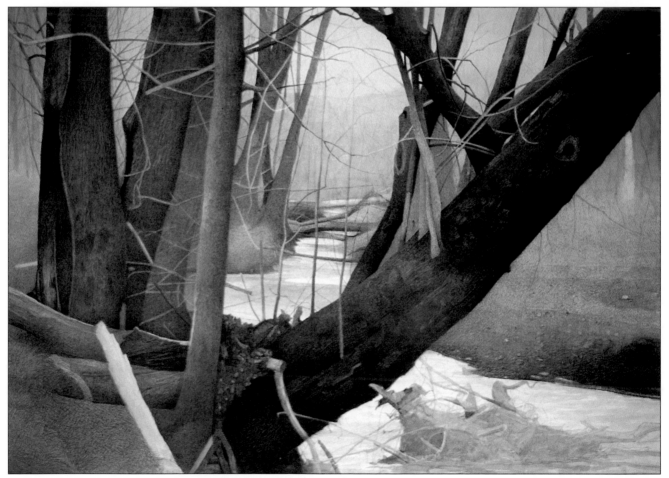

This absolutely beautiful painting is so sure in color, design, mood and depth. Strong, varied shapes and great values make this painting sing. While this is a realistic subject, I see a great abstract design in its color, shape and textures. Think of shapes, not water or trees. Try turning the painting and looking at it in other directions.

OZARK RIVERWAYS
Dean Mitchell, A.W.S., N.W.S.
22″×30″ (55.9cm×76.2cm)
Watercolor

18

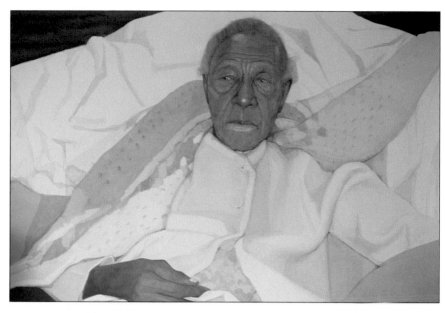

This painting is perfect. It has great values, design and whites. The face speaks volumes about the person Dean Mitchell has captured. This painting is a great abstract design. Forget there is a hand and face—just look at the shapes. Turn this painting in every direction.

ROWENA'S LAST VISIT
Dean Mitchell, A.W.S., N.W.S.
20″×30″ (50.8cm×76.2cm)
Watercolor

This is great abstract design. Though complex, this painting has a feeling of extreme simplicity. There is economy of line, a great cast shadow and every shape—no more, no less than needed—has a purpose. One of the shapes happens to be a figure, and what a figure it is.

BIRD IN FLIGHT
Robert Vickery, A.W.S.
31″×45″ (78.7cm×114.3cm)
Egg tempera

What great economy of line and simplicity in this wonderful painting. The textures, background and lines all lead to this wonderful figure. The cast shadow is perfect and the touch of red gives just the right spark. A great abstract design; a great painting.

THE APPLE EATER
Robert Vickery, A.W.S.
24″×36″ (61cm×91.4cm)
Egg tempera

19

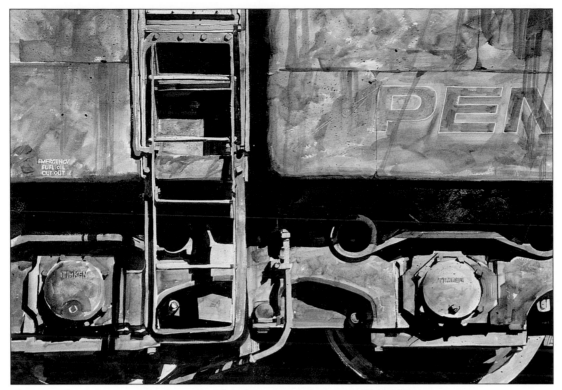

This is an abstract painting that happens to be of a realistic train side. The head-on view and flat space make it extremely abstract. Look at the masterful breakup of space. This painting has great value, texture and line. Look at this painting from every direction. Abstract designs are everywhere waiting to be discovered.

LOCOMOTIVE
Robert Sakson, A.W.S., df (Dolphin Fellow)
22″×30″ (55.9cm×76.2cm)
Watercolor
Awarded the Elizabeth Callan Memorial Medal, 1993
American Watercolor Society

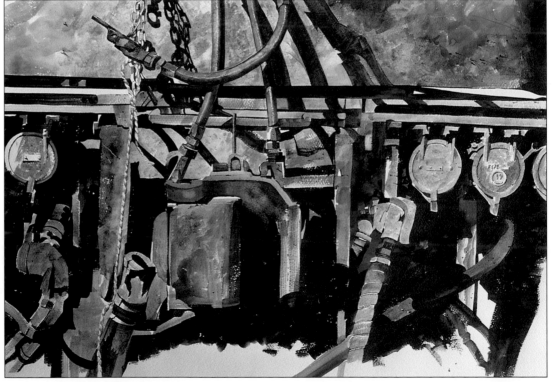

Another great abstract design that just happens to have a real train as its base. Great variety, color, value, texture and breakup of space. The darks are definitely not boring.

COUPLER
Robert Sakson, A.W.S., df (Dolphin Fellow)
20″×30″ (50.8cm×76.2cm)
Watercolor

Cultivating Ideas: They're All Around You

I'll tell you how I get my ideas and get started, then you can start too!

When I first started painting in a realistic manner, I would search for the perfect view and spot. I now can find something to paint at any spot. It might be shells on the beach, a crack in the sidewalk, a billboard, a wood pile. It might even be just the color I respond to, and I paint a non-objective piece as a response to my surroundings. I'm no longer interested in merely recording the whole scene. I still like to take time with an artist friend to paint on location, because it feels good and I like to touch base with the real world occasionally. But I prefer to paint in the studio and, rather than paint what's before me, paint what's in my mind's eye.

Photographic Prints

Photos are an important part of my work. I take extensive photos of subjects that interest and excite me. Rocks, water in myriad forms, abstract patterns on walls and old buildings are some of the themes that hold my interest. I use these photos as jumping-off points for my more abstract work. In more realistic work, like florals, I use more information from the photos, but I rarely copy everything that's there. I find it important to add my own information and not simply record. I let the painting lead me, then I go back to the photo for finishing details.

Corea, Maine

Maine Boatyard

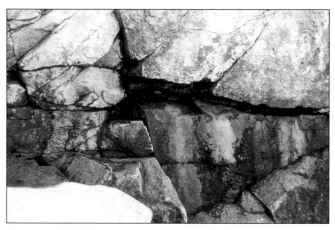

Maine Rock Wall

21

Ideas From Photos

I take abstract portions from realistic images and use them as jumping-off points, to get started. Getting ideas to paint can be as simple as seeing your subject in a whole new way. I seek out source material that lends itself to this concept and take photos that have a lot of information to use for these studies as inspiration for my abstract work rather than as literal references.

Sometimes, with luck, slides come back double exposed. I get ideas from this. I'm always looking for ideas. When I was spray painting house numbers and frames, I looked across the deck and saw their shapes outlined on the painting tarp. These kinds of things trigger ideas, and they just happened, so I shot some slides. You can generate ideas by getting involved in activities that make things happen, and bringing a good camera with film in it!

I get ideas from photographic prints enlarged or reduced on a photocopier. I crop sections, enlarge them and use these new images to start a painting. You can get wonderful abstracts this way—even from the most realistic photo. Seeing the black-and-white photo frees you to use creative color rather than the actual colors.

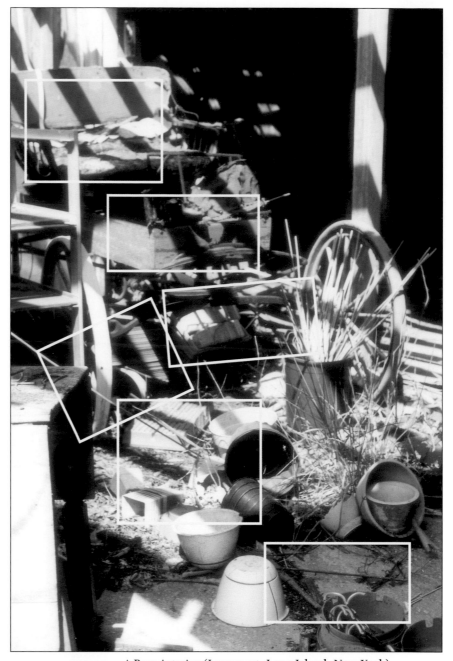

▲ Barn interior (Jamesport, Long Island, New York)
You can find better design ideas by looking at sections of your photos than you can make up—usually. You start with these and then let the painting direct you. This photo of an old barn interior has many areas that, when cropped with a camera's viewfinder, are perfect small abstracts. I have outlined some of these for you.

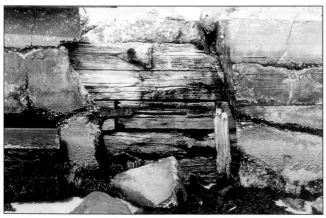

◄ Jetty (New Suffolk, Long Island, New York)
I compose through the viewfinder of my camera. This close-up of a jetty is a perfect example of close-up shots I like to take. It has great texture and design. It's a painting waiting to happen. Remember that even though the sea wall is horizontal, you can make it vertical. Would you keep the earth colors, or change the wall to red or blue? You could even make it magenta! It's so exciting that you don't have to be bored. You can make things the way you want. Choose the color and the design. It's just a matter of opening your mind to the possibilities before you. You're the artist. Learn to use a camera creatively and get busy gathering source material.

Interior of summer house (Southold, Long Island, New York)
I purposely compose with my camera as a viewfinder. I look through the lens and pan until I see good compositions that could direct me in abstract paths. This photo has good elements to work with. Start looking at your world.

Double exposed slide
A mistake can become a success rather than a failure. I think the double exposure makes this abstract painting look intriguing. Next time I can try to use bands of color. I didn't even have to think of the idea; it was given to me. Be on the lookout!

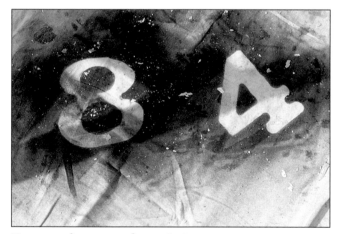

House numbers sprayed on painting tarp
After spray painting numbers for my house, their shapes were left on the tarp. When I looked at it from a distance, I thought, *Isn't that great!* I grabbed my camera. I may or may not ever use it, but I have it to consider. The idea could lead to putting words in a painting instead of numbers. You never know. That's why being an artist is so much fun. Remember, it's all in the attitude.

Frame silhouette sprayed on tarp
The white right angle was left after spray painting a frame on a painting tarp. The blue and black were there from previous projects. Is this a great abstract underpainting, or what? Combined with the 84, it just might win a prize.

Your Own Shapes

Abstract shapes from within my own paintings generate ideas for new starts. One of my favorite sizes is 29″×40″ (73.7cm×101.6cm). It's amazing how many starts I can find within this surface. These small design ideas from my own work are often better than anything I could think up. Extracting ideas this way also enables an artist to come up with a new look. As artists we so often copy ourselves. Sometimes I literally take small designs from larger paintings. Sometimes the small designs are such gems that I just cut up the larger piece, embellish it slightly and end up with a great new small painting. You can really learn design this way.

Detail from a larger painting
This is enough to get me started on another painting.

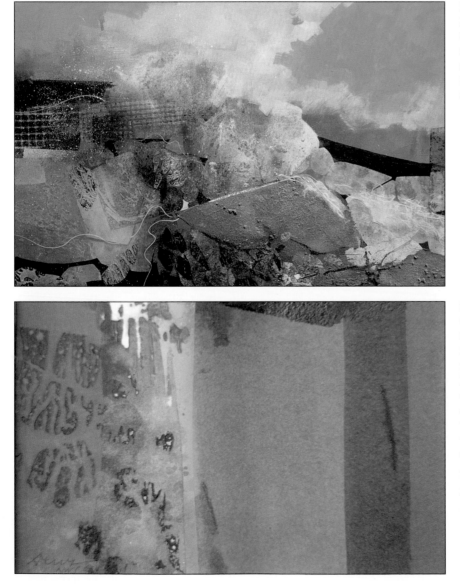

Detail from an acrylic collage on canvas
I work on canvas, as well as paper, using the same techniques. Working in different mediums will make you a better painter. I also do printmaking when I can. You learn from everything you do. Broaden your horizons. Aim high!

Small paintings with ideas taken from portions of larger pieces or pieces cropped from these larger pieces are often my best. There is something very special about small paintings. They make you come in for a closer look. This painting is small in size, but big on impact. This little gem has good breakup of space, good color (predominately cool with just the right amount of warmth, good use of complements) and good values. Who says big is better!

FLOATING FRAGMENTS II
3⅝″×5⅝″ (9.2cm×14.3cm)
Watercolor and ink on paper
Collection of Mr. & Mrs. Richard Stein

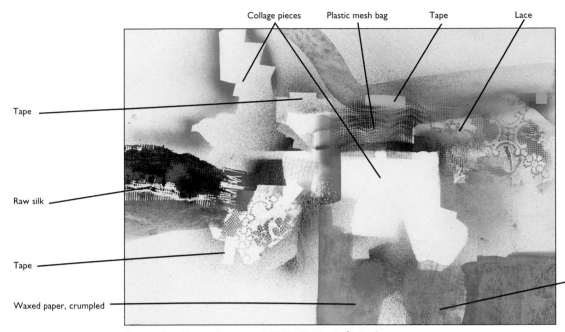

Collage pieces Plastic mesh bag Tape Lace

Tape

Raw silk

Tape

Waxed paper, crumpled

Waxed paper, flat

Sprayed collage pieces on 140-lb. (300 g/m²) Arches paper
Spray paint different shapes and items to get started. This is not a finished painting; it is one way to get started. Simply take pieces from your collage box, tape them on the paper in a pleasing arrangement and spray paint with a mouth atomizer. I continued spray painting through raw silk, a plastic mesh bag and lace. Next I decided to start painting and used waxed paper, both crumpled and flat, for texture. I also did a waxed paper transfer. See the texture mini-demonstrations in chapter two to see how I do this. You can practice techniques this way while creating an abstract painting. Who says doing studies has to be boring! By spraying, you get instant coverage of your white paper and the fear is gone.

Think Small
You don't have to paint large. Strong color and value are evident in this small design. Rice paper, Japanese tea chest paper and watercolor papers were used in this piece. Silver and gold papers make you feel this painting is indeed a small gem. This painting gave me signature membership in the National Collage Society and received an award at the Annual Exhibition.

SNOW RIDGE
6″×6″ (15.2cm×15.2cm)
Watercolor and acrylic collage on paper

Ideas for Starts and Finishes: Two Artists Interpret a Photo

In this section you'll see how two artists interpret the same photo. The photo Dorothy Skeados Ganek and I interpret here was taken at Presby Iris Gardens in Upper Montclair, New Jersey. Everywhere you look are beautiful irises, and it would be hard to not be inspired. This particular photo has good color, value and design. My step-by-step demonstration is a more direct interpretation, using the iris itself as the subject to be painted. Dorothy Skeados Ganek uses a more abstract approach, letting the feeling of the moment and the visual excitement of the color direct her painting.

You'll clearly see there is no one way to paint and no one interpretation. Whether you interpret the photo literally or abstractly can also vary from day to day. This is where a series is helpful. You can see how many different ways you can say "iris." Try to interpret this photo and see how your painting compares with ours. Don't concern yourself with our approach to the subject; use what this photo says to you.

DEMONSTRATION I
Kool, Cool Iris by Pat Dews
21″ × 29″ (53cm × 74cm)
Watercolor, acrylic and ink on printmaking paper

Inspired by the colors and values in this photo, I decide to create a painting. This is how I'm painting this iris today, not necessarily how I might paint it tomorrow.

The final version, which has an almost jungle-like feel, is directly influenced by my Florida home, where I'm surrounded by this dense, leafy, vine-covered environment.

Following is an interpretation of the photo and my thought processes as I paint, edit and make changes. Sometimes the changes are better,

Photo of irises taken in New Jersey

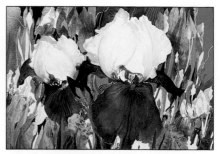

Finished Painting

KOOL, COOL IRIS
21″ × 29″ (53cm × 74cm)
Watercolor, ink and acrylic on Arches 140-lb. (300 g/m²) cold-pressed watercolor paper

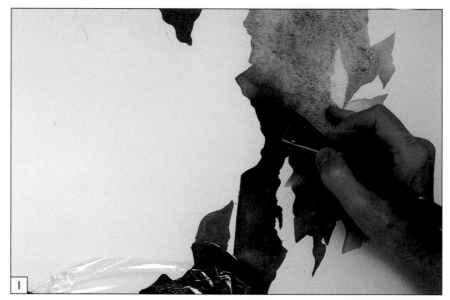

and sometimes they are worse. I don't preplan; I plan as I go. This is how my paintings develop.

Painting Around Top Petal

On dry Arches 140-lb. (300 g/m²) cold-pressed paper I begin painting around the top petal of the larger iris with a 1-inch (25mm) flat. I lay washes of Alizarin Crimson, Burnt Sienna, Cerulean Blue, Sap Green, Raw Sienna, Ultramarine Blue and Mahogany. Since the petal is white, I am forming the petal by painting the spaces around it. Remember as you paint that you always have choices to make. You are the artist, and you decide. Had I wanted to paint a portrait of the iris, I would have made a careful drawing.

TRUST YOUR INSTINCTS

There is no one right way to paint a subject. Every artist is unique and has a different vision. This is what makes painting special. You can see what someone else paints and the interpretation she brings to a subject, but your way could be better. Learn to trust your own instincts.

26

- Arches 140-lb. (300 g/m²) cold-pressed watercolor paper
- toothbrush
- brayer
- waxed paper
- Saran Wrap
- Liquitex gesso
- mouth atomizer
- paper towels
- plastic mesh bag stencil
- frisket film
- Brushes:
 1-inch (25mm) flat (Grumbacher Sabeline Aquarelle 6142)
 no. 12 round (Winsor & Newton Series 101 Sceptre Gold)
 no. 4 round (CJAS Water Hawk)
 no. 2 rigger (Grumbacher)
- Winsor & Newton Artists' Water Colours:
 Alizarin Crimson
 Burnt Sienna
 Cadmium Orange
 Cerulean Blue
 Cobalt Blue
 Cyanine Blue
 Raw Sienna
 Sap Green
 Ultramarine Blue
 Yellow Ochre
- Winsor & Newton Designers' Brilliant Liquid Water Colour:
 Burgundy (diluted)
- Dr. Ph. Martin's Radiant Concentrated Watercolor:
 Mahogany (not lightfast)
- Liquitex Acrylics:
 Burnt Sienna
 Phthalocyanine Blue
 Cobalt Blue
 Alizarin Crimson
 Cerulean Blue
- Shiva Acrylic:
 Yellow Ochre
- FW Acrylic Artists Ink:
 White
 Flame Orange
- FW Drawing Ink:
 Indigo (diluted)
 Turquoise

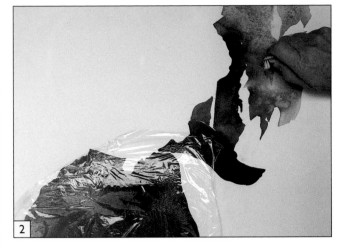

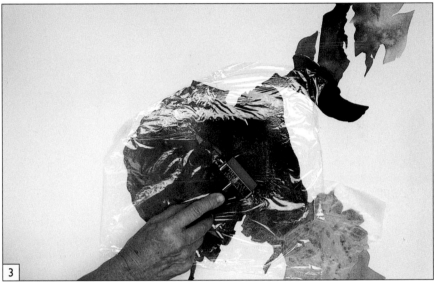

2 Spritzing Texture

I dip a toothbrush in clear water and spritz it into the almost dry paint to make water marks for texture. You can control the size of the water marks by how much water you spritz, how wet the wash is and what you spritz with. I used a toothbrush, but I could have used a paintbrush.

3 Painting Lower Petal

With a 1-inch (25mm) flat, I paint the lower petal of the large iris with washes of Alizarin Crimson, Burnt Sienna, Cerulean Blue and Ultramarine Blue. I use Cerulean Blue because I want to, not because it's there. It contrasts nicely with the rust and wine colors I plan to use. I round the left side of the petal so it won't look as tongue-like as in the photo. I continue a wash of Alizarin Crimson and the Cerulean Blue to make a mauve amorphous shape adjacent to the lower right of the petal for the same reason. Notice that I am painting different values. Into the wet—but not too wet—washes I press crumpled waxed paper into the mauve shape and Saran Wrap into the petal shape with a brayer. This will create texture for contrast and interest. While the paint is still wet, you can see the forming pattern and make adjustments if necessary. Removing the papers before the paint is dry lessens the textural effect.

4 Modeling the Petals and Creating Leaf Shapes

Mixing Cadmium Orange, Mahogany, and Yellow Ochre with Cobalt Blue, I use my no. 12 round to model the petals and give them form. I use more of one color than the others in some instances to vary the color. I stand when I paint and give a free upward swing to model the line in the center of the one right petal and in the middle, separating the petals where they overlap.

With my 1-inch (25mm) flat, I paint more leaf shapes and place Saran Wrap in the wet paint for texture. For my greens I use mixtures of Cerulean Blue and Burnt Sienna, Cerulean Blue and Raw Sienna, Cyanine Blue and Burnt Sienna, and Sap Green and Raw Sienna, cutting some of the mixtures with Alizarin Crimson. Red and green are complementary colors. Paintings often look better with mixtures of complements. I use a brayer to press the wrap in place and remove it when the paint is dry. Don't get anxious and remove it too soon.

THINK VARIETY AND CONTRAST

Strive for contrast in all areas of your painting. Think color variation! Think temperature variation!

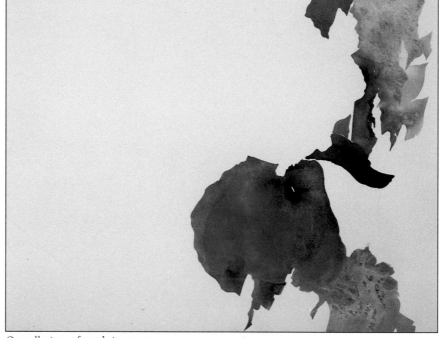

Overall view of work in progress

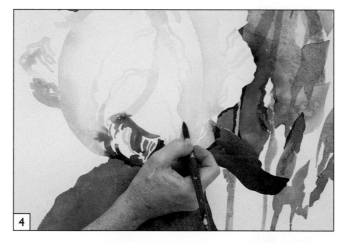

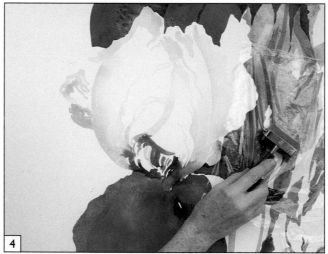

5 Painting the Smaller Iris
Using my 1-inch (25mm) flat, I paint the lower petal of the smaller iris. I use a mixture of Alizarin Crimson, Burnt Sienna and Ultramarine Blue. I paint in more leaf shapes with the same green mixtures used previously. I once again add texture with Saran Wrap and waxed paper for consistency. I switch to my no. 12 round for modeling the top of the iris. I use the same mixture of Yellow Ochre and Cobalt Blue and add some Cadmium Orange.

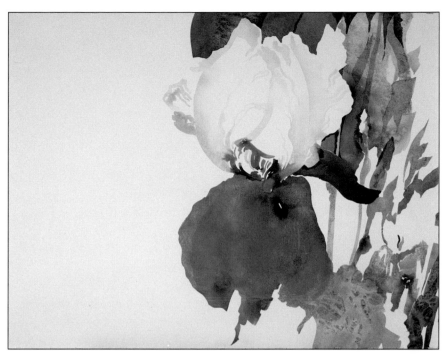

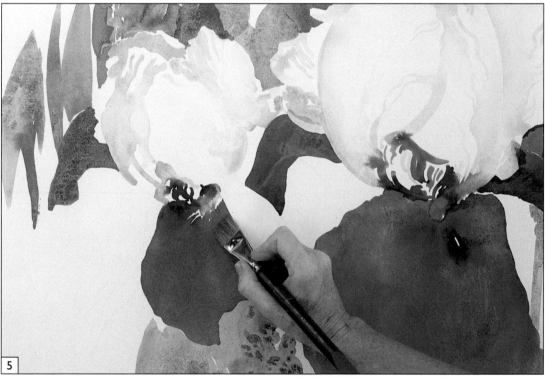

EXPERIMENT WITH IDEAS

Try out the different ideas you get as you paint. One idea feeds another. The important part to remember is that you have painted, that you have made an interpretation, and that this doesn't have to be a final, definitive statement. You will like some paintings better than others. The truly great paintings are hard to come by, and that's why they are so special.

6 Shape and Texture

I paint another amorphous shape in the lower right, under the bottom petal of the smaller iris, using Alizarin Crimson and Cerulean Blue for my painting mixture. I use a brayer to press crumpled waxed paper into the wet wash.

7 Determining Values

The left "winged" petal of the larger iris looks suspended in air at an odd angle. A mauve shape painted with a mixture of Alizarin Crimson and Cerulean Blue bridges the gap between the irises, carrying down the color in the leaves above the gap. I also decide to put in some darks. I use a no. 4 round to paint small negative spaces with a mixture of Burnt Sienna, Phthalocyanine Blue acrylic and gesso. This rich, dark opaque contrasts with the transparent areas, making the lights pop out and giving impact to the painting.

8 Bud and Leaves

I now paint in my iris bud with a no. 12 round, using a mixture of Alizarin Crimson and Ultramarine Blue. I use a mixture of Raw Sienna and Sap Green for the leaves. This combination of green and purple alone gets me excited and makes me want to paint! I add leaves to the lower left section of the painting.

JUST DO IT!

There's no magic formula to painting. Just learn things that work for you and do them. Take constructive advice from artists with more experience when you're first learning; they've painted hundreds of paintings and have already made mistakes. They'll help you become a better painter faster and easier. For example, watercolor artist Barbara Nechis once told me that it's really harder to do abstracts without using opaque paint and acrylics. I took her advice and had more success.

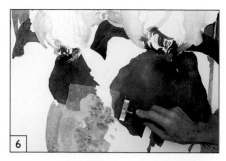

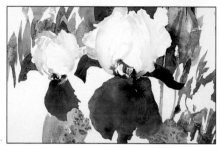

Overall view of work in progress
I like the whites and hope to leave some; the painting looks so clean at this stage. What shall I do with the bottom left?

CONTRAST AND INTENSITY

Good values give your painting contrast and intensity. It's easier if you establish them at earlier stages of a painting, because then you know what adjustments you need. Once I determine my darks, the rest falls into place. If you're unsure of where to put darks, plan as you go by testing them with colored paper scraps. If your painting has good values, that may be all you need. It's easy! Just consciously make good value changes.

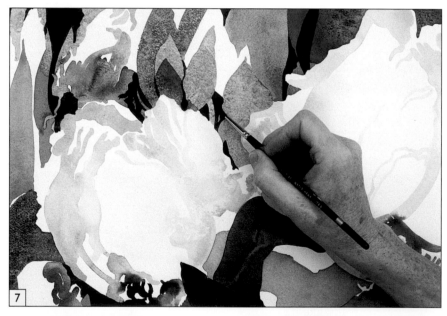

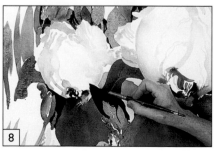

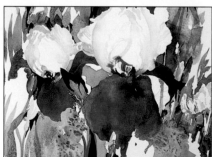

Overall view of work in progress

9 Spraying a Gridlike Pattern

The mauve between the flowers does nothing for me, and the Cerulean Blue looks too isolated on the lower large iris petal. I decide to use a plastic mesh bag stencil (used to package oranges) to spray a gridlike pattern of blue to cover the mauve, allowing some of the mauve to show through while adding interest. Spraying with a mouth atomizer allows me to make this color change without disturbing the color underneath. Be sure to cover areas you don't want to spray. The atomizer should be held perpendicular (a little more than the slide indicates) to the jar of diluted Indigo ink. Unfortunately, I didn't wash the grid after the previous spray; the old color became wet with addition of the new color, leaving a deposit of Mahogany from the prior spray and another change to make. I must fix it and remove the unsightly drip.

10 Lifting Out Leaves

I scrub out a leaf to the right of the large iris using a paper stencil and a toothbrush dipped in water. After scrubbing and lifting the color, I remove excess water with a paper towel before lifting the stencil so as not to disturb the adjacent painting. I lift two leaves from the section above the winged petal of the smaller iris on the left, and in the lower left leaf section. I don't like that the amorphous shape to the bottom of the smaller iris is similar to the one at the lower right. I really like the whites, and the lifting helps. I spray diluted Indigo ink through the plastic mesh bag stencil on the leaves in the upper left to move texture through the painting.

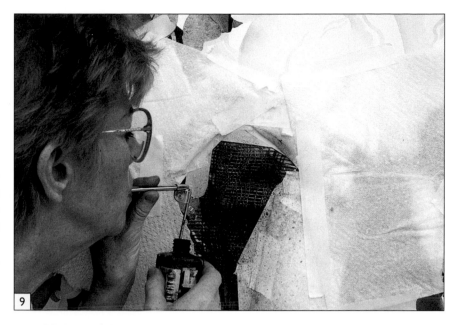

MASKING MATERIALS

I use anything at hand as a mask: frisket film, paper towels, scraps of paper, waxed paper and masking tape, to name a few.

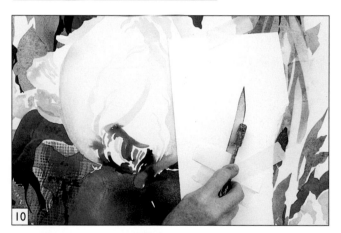

THINK BIG!

I only use a small brush in small spaces, because I find that I piddle when I use a small brush. Don't be afraid to use a big brush and a full sheet of paper. Go for it!

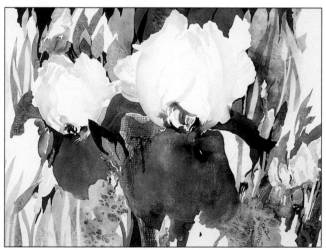

Overall view of work in progress

11 Spraying Color Variations

After scrubbing out the unsightly drip left by the plastic mesh bag mistake, I still think I'd like more blue. Will I ever finish? Using the frisket film and paper towel as a mask, I use a mouth atomizer to spray diluted Indigo ink into the upper left white section and let it dry. The result looks very blue, so I immediately spray a mixture of diluted Burgundy and Indigo for color variation, let that dry, then spray white liquid acrylic over these two layers to make the area look less dense. I hope I like it; it's always a surprise when the masks are removed. At least I'm not bored!

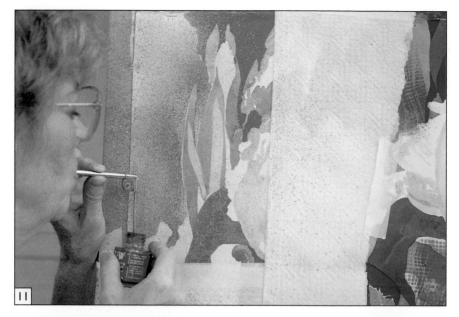

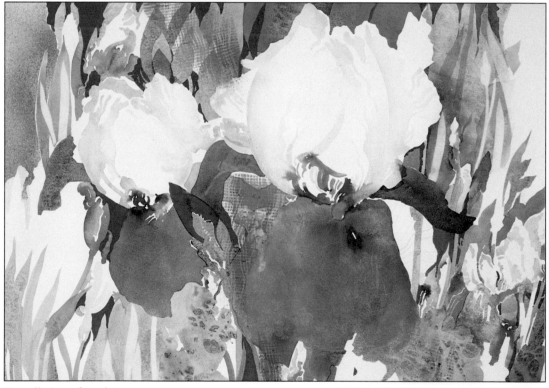

Overall view of work in progress

The spray makes the blue on the larger iris less isolated, and the painting now looks more integrated to me. But I feel that the one sprayed area looks too isolated. I always repeat colors and textures throughout the painting. The bottom petal on the smaller iris doesn't look grounded to me. I further feel that I have to put some modeling in the white flowerlike shape on the bottom left. It just doesn't look right with the flower on the right more finished.

PIECE BY PIECE

I'm concerned with colors and shapes. My paintings are puzzles that fit piece by piece.

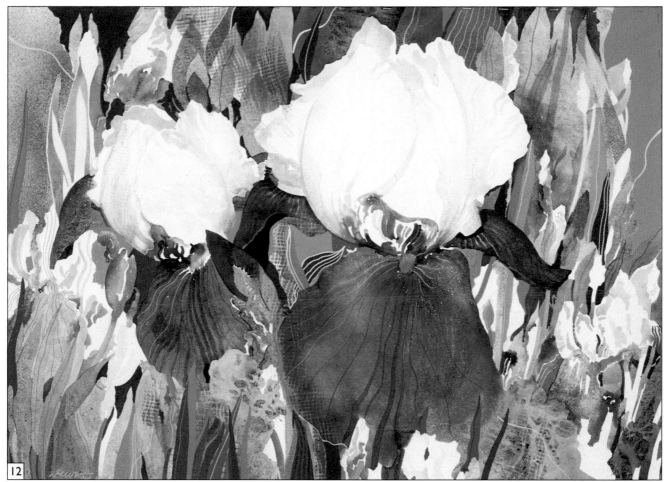

12 Finishing the Painting

I paint out the last white areas, spraying a blue leaf at top right that makes viewers' eyes move right to left and back to the center of interest. Done in Burnt Sienna and Phthalocyanine Blue acrylic mixed with gesso for a grayed blue-green, this shape echoes the leaves at top left. I used these colors in step 7, but results differ depending how much of each color is mixed. This color complements the others, so I use it throughout the painting; for a solid area between flowers, cleaning up the scrubbed-out spill and unifying the painting.

I model the lower left white flower shape with an Alizarin Crimson, Cerulean Blue and Cadmium Orange mix. Texture is added at lower left by spraying Indigo through the plastic mesh bag and adding leaves. Additional leaves, and one more leaf at the upper left fills the blue area. These leaves are mixes of Burnt Sienna acrylic, Phthalocyanine Blue acrylic,

and gesso. Hues differ due to varying color proportions in the mixtures. Leaves are added using Cerulean Blue, Alizarin Crimson Hue Perm acrylic and gesso. Lower petals are modeled using a rigger with an Alizarin Crimson, Burnt Sienna and Ultramarine Blue mix.

Texture was produced in top and lower sections by spraying through the mesh bag, but there's very little in the middle ground. I spray white acrylic through the bag on the small iris's top petal, then model the petal with a Cobalt Blue, Yellow Ochre and Flame Orange acrylic mix. Whites are reclaimed with gesso. The white spot on the larger iris's bottom petal is in a dark hole, so I scrub the dark and fill with an Alizarin Crimson, Burnt Sienna and Ultramarine Blue mix. Spattering Cerulean Blue and acrylic white with a toothbrush covers the scrubbed dark. Finished!

This painting is a hard-edged, predominately cool environment to

Finished painting

KOOL, COOL IRIS
21″×29″ (53cm×74cm)
Watercolor, ink and acrylic on Arches 140-lb. (300 g/m²) cold-pressed watercolor paper

showcase my irises, and something to work against for my next attempts. I can't wait to do a loose, soft-edged painting!

YOU'RE THE ARTIST

I often wonder if I should have used a different color from the one I used in a particular stage of a painting, then I go back and change things. Instructors have pointed out to me that I paint three different paintings in one, and it's true. I've finally come to terms with my style of working; I seem to need to see it to believe it. Take instruction and advice, but in the end, you're the artist, and you must decide. For better or worse, you have your own style. Learn to love it!

DEMONSTRATION 2

Fleur-de-Lis by Dorothy Skeados Ganek, A.W.S.
22" × 30" (55.9cm × 76.2cm)
Watercolor and acrylic on 140-lb. (300 g/m²) hot-pressed paper

Early Color and Texture

1 I begin the painting as a horizontal, later switching to a vertical in step 5.

Translating the photo into my own visual language, I partially wet a stretched piece of hot-pressed watercolor paper with clear water. I load a large flat brush with paint and flow it onto the wet paper. I lift my flat brush horizontally, leaving behind vertical lines showing the white paper. To incorporate texture early, I use a brayer to roll colors that inspire me from the photo.

Crushed Waxed Paper

2 Partially wetting the paper allows me to achieve soft edges and hard edges at the same time. The colors bleed together, emerging as new shades. On the left side, I place a piece of crushed waxed paper into a wet pool of French Ultramarine and Alizarin Crimson, which mix together to become a cool purple. It's left there to dry before I peel it away later to reveal the texture.

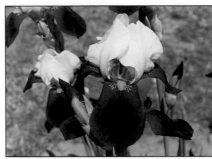

Photo of irises

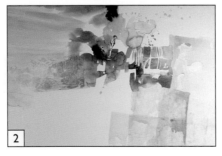

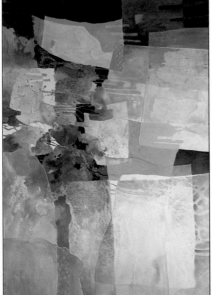

◄ Finished painting

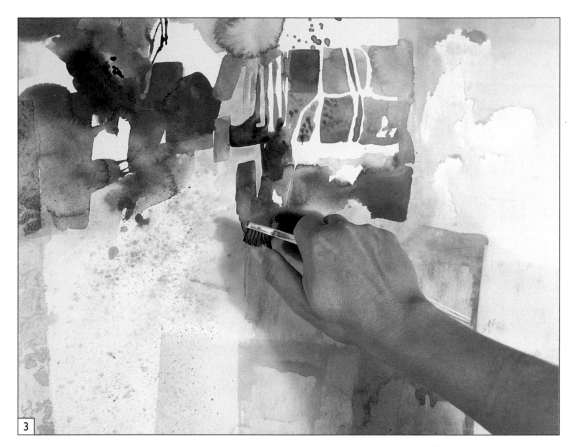

3 Spattering Cool Texture
I wet the white areas with clear water and use a toothbrush to spatter diluted Ultramarine watercolor to create texture, at the same time attempting to balance the warm colors with the cool ones.

4 Developing the Composition
More crushed waxed paper is used to continue the previous texture, giving me a vertical hard edge which I can use in developing the composition.

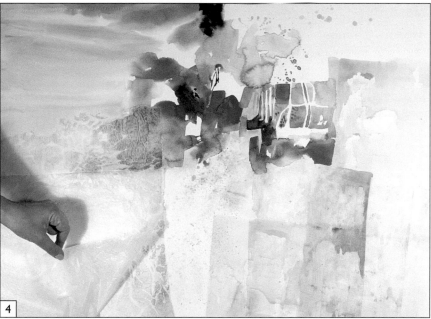

5 Changing to a Vertical Format
After studying the painting for a long time, I decide a vertical format is more interesting. I add depth by adjusting values with diluted acrylic in the point-of-interest area. Adding water to acrylic gives me vivid washes that are soft and transparent. The greens at left are mixes of Cerulean Blue and Naples Yellow, as well as Ultramarine and Yellow Ochre.

6 Plastic Packing Material
Additional texture is accomplished by pressing plastic bubble packing material into wet pigment and letting it dry before removing.

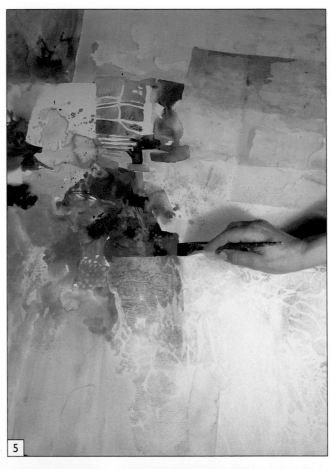

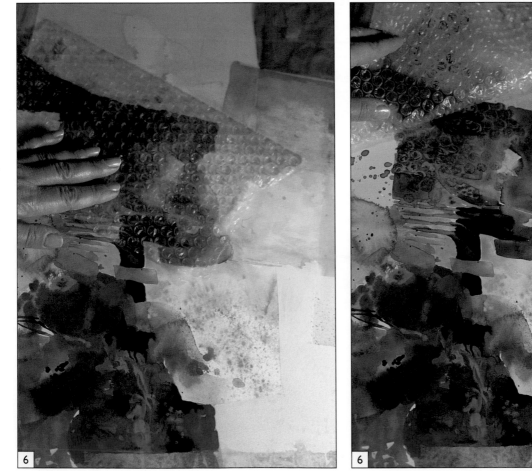

7 Defining Forms With Glazes

Continuing with a glazing technique, I contrast values and define forms. The small circles created by the bubble pack are repeated in other areas by painting the negative space around dots with a fine round sable brush.

8 Preserving Whites While Enhancing Forms

In order to preserve the white in the painting, a template of torn paper is used while a toothbrush spray enhances the form on the left. Masking tape strips protect horizontal white shapes.

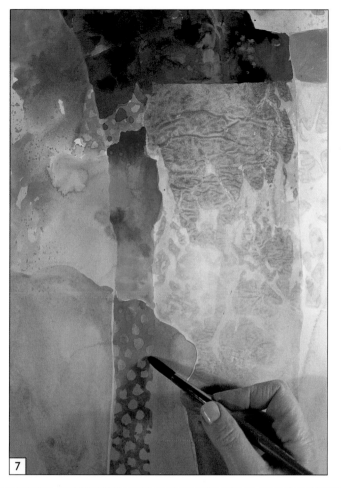

7

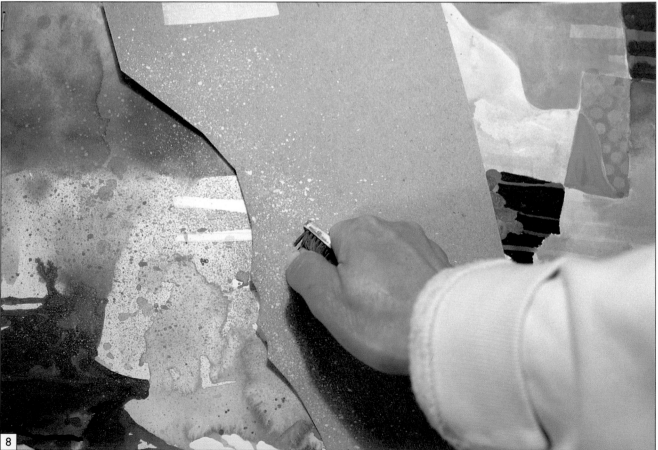

8

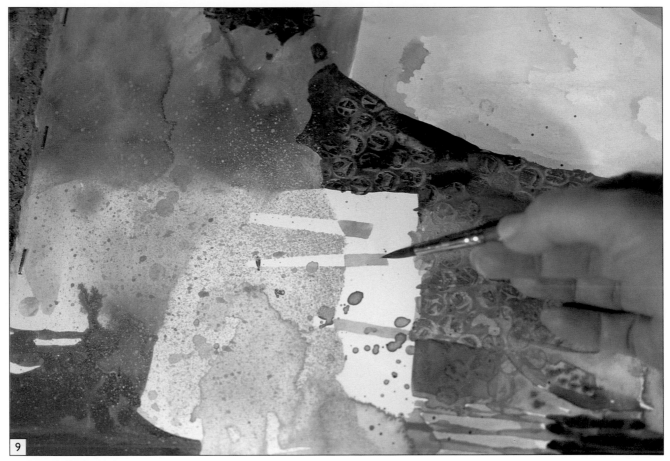

9 Adding Detail
After the masking tape is re-moved, detail is added with a very fine round sable brush, completing the horizontal shapes.

10 Darks and Whites

I resume building the composition by carving out large geometric shapes using dark acrylic opaque paint. I mix acrylic Phthalocyanine Blue, Raw Sienna and Alizarin Crimson to create a rich black.

After careful consideration I determine that I've lost too many of the white areas in the painting. I restore some of them by using a plastic-tipped bottle filled with liquid Titanium White acrylic paint, applying it much like using a brush around shapes that I want to enhance.

In the final stage of completion I'm very careful about making changes, using torn white paper to determine if more white is needed before actually painting it in.

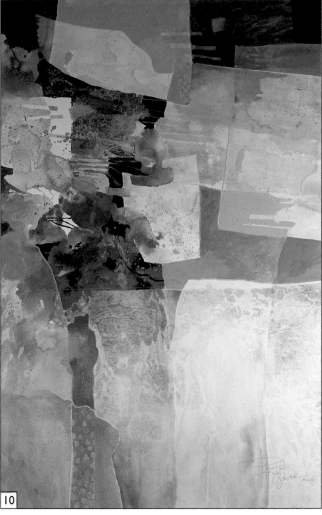

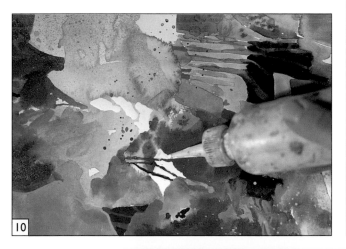

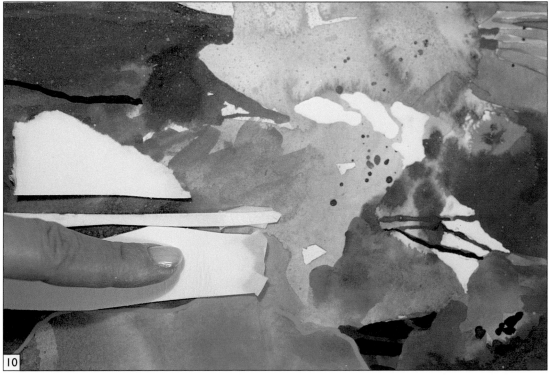

11 Carving Out a New Shape
Using a scumbling technique and a stiff acrylic brush, I carve out a new shape using opaque acrylic paint.

ANOTHER INTERPRETATION

Ganek says, "It has always been fascinating to me that abstract painters will translate a visual experience into a work of art that is totally personal and different from my own.

My painting *Garden Wall* is a good example of this phenomenon. On this particular day I got together with a few artists friends at the home of Pat Dews to paint, to talk and to eat delicious things. . . . We did this as often as we could because the energy that we created when we were together showed up in our work in a very positive way—at least it did for me. Pat took out a pile of photographs from her files for us to use as inspiration, and I quickly chose the most exquisite iris picture.

As I held it in my left hand, my right hand began gliding watercolor washes across a piece of watercolor board. What I saw initially in this photograph was color. The subtle gradation of the purples bleeding into the earthy rust tones was very exciting to me. The delicate iris petals appeared to have a velvety texture which convinced me to leave the paint alone as much as possible. The texture in this painting was achieved by crumbled waxed paper laid into washes and pressure applied over it using a roller to smooth it. As I did this, excess pigment from under the waxed paper was squeezed out, so I continued to drag it across the paper, leaving the most interesting effect. Now I saw new possibilities to the use of this roller, and the excitement was born from three components:

• Being in touch with the mood of the day and my strong emotional response to the iris photo
• Translating the color and texture of the iris into watercolor on paper
• Allowing an accidental result to turn into a creative development."

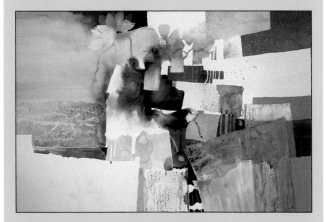

GARDEN WALL
Dorothy Skeados Ganek, A.W.S.
20″ × 29″ (50.cm × 73.7cm)
Watercolor and acrylic on Strathmore board

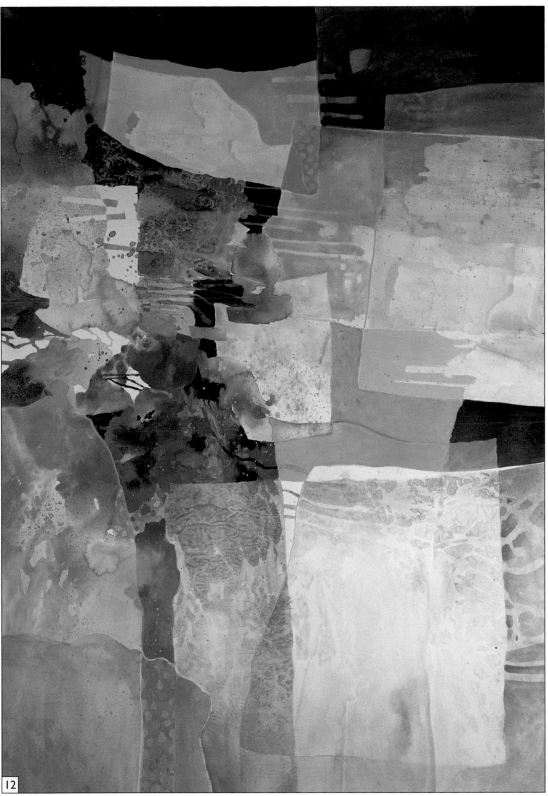

12 Finish
As I compare the iris photograph to my completed painting, I think they share similar characteristics: delicate layers of earthy rust tones and shapes defined by a variety of green textures.

FLEUR-DE-LIS
Dorothy Skeados Ganek, A.W.S.
22″×30″ (55.9cm×76.2cm)
Watercolor and acrylic on Arches 140-lb. (300 g/m²)
hot-pressed paper
Collection of the artist

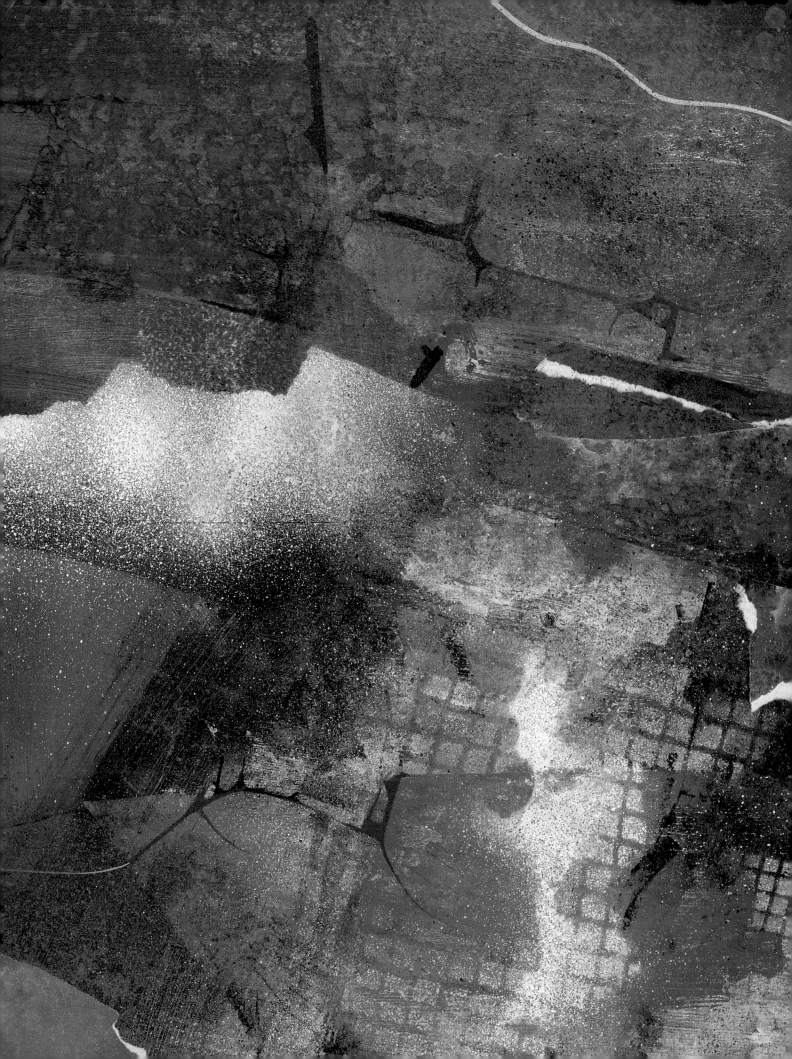

A Broad Vocabulary of Techniques

TEXTURE STUDY 25
22⅛″×24¾″ (56cm×63cm)
Acrylic, ink and watercolor collage on no. 80 cold-pressed Bainbridge board

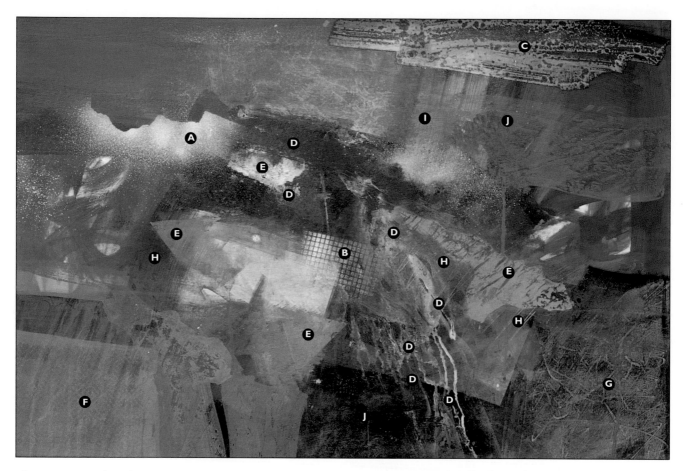

This is *Texture Study 25* (pages 42-43) in progress. As I demonstrate techniques and textures in workshops, I find it best not only to try these techniques, but to try to make a painting at the same time. This way, I paint the technique and learn about design and color at the same time. It makes learning fun. As you build layers, try glazing, alcohol spritzing, spattering, waxed paper and Saran Wrap techniques. Spray through grids and fabric, scratch out, rub off with alcohol, comb, scumble—any other technique you feel like trying. As I paint, I build a rich surface I can quiet and shape into a finished painting. This way I ruin one piece of paper (which can be fixed) or get a prizewinner.

LEGEND

A Stencil spray
B Grid spray
C Alcohol rub-off
D Alcohol spritz
E Waxed paper transfer
F Paper towel lift
G Bottle rim markings
H Scratching out
I Crackle paint
J Scumbling

Techniques and Texture Mini-Demonstrations

In this section I demonstrate some of the techniques I use in my paintings. They are simple to follow. As you practice these techniques, you will not only learn about the various techniques, you will learn about color, paper and how to use various tools. I do not state which color, paint or paper I use unless it is germane to the technique. You should try different colors, paints and papers to become familiar with all of them. Look for other techniques throughout the book. I have learned new techniques because I'm trying new products. You will, too.

Fun of Discovery

It is great fun to place different papers and objects in wet washes, then lift them when the paint or ink has dried. Sometimes, I can hardly wait for the washes to dry. Any object left in wet paint or ink will leave a mark if left on until the wash dries. I find it very exciting to discover the texture that is made.

It's hard for me to remember how I could have painted without using these different techniques and textures. If I can make a texture by using a tool, I don't see any great value in having to use a brush to try to make the same mark.

Application of Techniques and Textures

These textures are not just for the abstract painter. Realistic painters can texture wooden barns, stone buildings, flowers, leaves and vases, for instance. These textures can be used to render rocks, mountains and trees in landscapes, or to prepare backgrounds for figure studies. The list is endless. All you need is imagination and a willingness to try something different.

Techniques Are Not a Painting, But Can Be

I find it's great to practice many of these techniques at the same time on one piece of paper or illustration board. It's a challenge to create a painting whose basis is texture and technique. As I use the techniques, I move color through the work, vary-ing sizes, shapes and textures. As I practice the techniques, I am also thinking of design elements. In using color I think about value, intensity, temperature and dominance. Techniques alone do not make a painting. What you do with these techniques is what makes a painting. When examining a painting it's possible to detect these techniques, but when looking at a painting you should see an integrated whole, not just a series of techniques.

After practicing these techniques individually, it would be good for you to try to create a painting using a combination of them. Remember, you are just learning and practicing; it's supposed to be fun! If you get a good painting as well, what a treat! These practice sheets can be cropped into small paintings if they don't work as a whole.

Another way to try these techniques is to use blank watercolor postcards. You will get practice, and your friends will receive original pieces of art.

Let's look at some of the techniques I use in my paintings.

Sprinkle, Spritz and Wash

Hard Edge, Soft Edge

1 Wet part of the paper in a pattern, as if you were painting, and leave the rest dry. Then drop or paint your paint into the wet channels. You will get a hard edge and a soft edge at the same time.

2 Isn't it great how this works? Notice the birdlike shape I unknowingly painted. This gives me the idea that I can paint a shape with water and then fill it with color. This shape could stand separately in the painting.

Watermarks

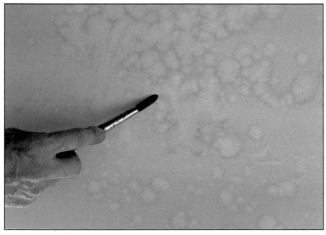

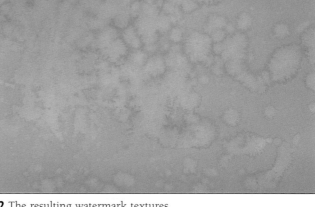

1 After dipping a small round in clear water, I flick my wrist to let water spatter a nearly dry ink wash. If the wash is too wet, nothing happens. The size of the watermark depends on the size of the brush and the amount of water. You can use a toothbrush effectively as well. You can use this technique to make flowerlike shapes, snow or just texture.

2 The resulting watermark textures.

Alcohol Texture

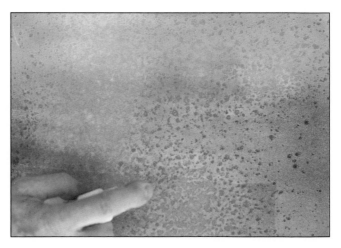

This texture is perfect for rock and water paintings. Lay a wash of ink on BFK Rives printmaking paper, then spritz alcohol from a spray bottle into the wet wash. The BFK Rives paper makes dark spots where the alcohol hits it.

Alcohol Spritz

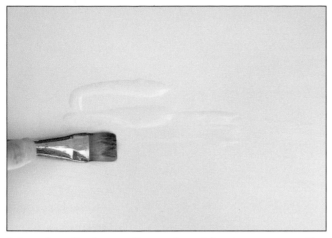

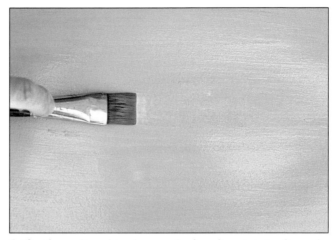

1 Spread acrylic gloss medium and varnish onto your paper. The alcohol works best on a coated surface.

2 After the medium dries, lay a wash of acrylic paint. Acrylic works great with alcohol.

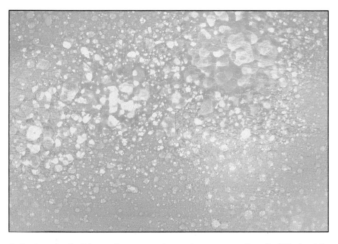

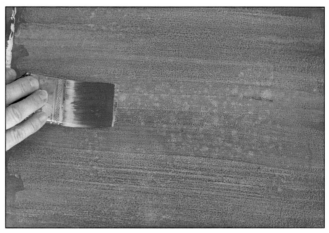

3 Spritz alcohol into the wet paint using a spray bottle filled with regular rubbing alcohol. The white surface will become visible.

4 Lay another acrylic wash.

5 Spritz again to reveal the yellow surface and a little of the white. You can build up many layers of alternating color this way.

Salt Texture

Sprinkle regular table salt into a damp watercolor wash. Be sure to let the wash dry slightly before sprinkling the salt. Brush the salt away when it has dried. The salt absorbs the color. Be sure to remove all the salt so moisture doesn't accumulate. For larger spots, salt a very wet wash or use kosher salt.

In this example I sprinkled salt into a much drier wash, so the spots aren't as large.

Bleach Texture

1 Paint a wash of ink. (Ink seems to work best.)

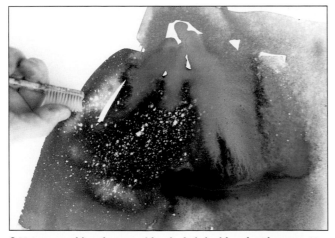

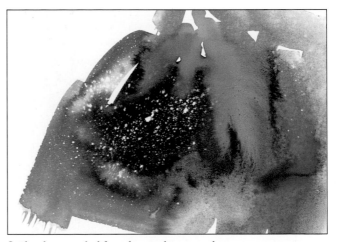

2 Using a toothbrush, spritz bleach slightly diluted with water. Use ventilation with bleach, place it in a marked container and keep it out of the reach of children.

3 Bleach not only lifts color, it changes color.

Resists

Crackle Glaze Technique

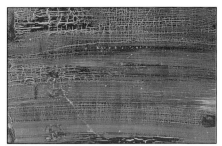

1 Apply a wash of acrylic paint to illustration board. (I just finished using crackle glaze on a piece of furniture, and I decided it could work on illustration board as well.)

2 Apply a thin coat of crackle glaze (Paint Magic, Jocasta Innes) over the base color. Brush the glaze on vertically.

3 When the glaze is dry, brush on a top color horizontally. The thickness of the top-coat will determine the size of the cracks. Do not rebrush once cracks begin to appear. In subsequent layering, after the glaze with the cracks dries, too much water or layering will lift the crackle glaze. It's best to spray over it, which doesn't disturb it, leave it alone or make only one additional glaze—not too wet.

Wax Resist

1 Using a ruler as a straightedge, I guide the block of paraffin along the edge. In this way I draw a straight line with the paraffin on my paper.

2 I lay a wash on the paper, and where the wax lines were drawn, the paint resists. This is another way to draw a line. In the section Capturing Trees, Rocks and Water (pages 82-99), I will show you how I use wax resist to create the foam in water. Wax lines can easily make a grid pattern and interesting outlines. If you wanted to have flowers outlined, draw with a piece of wax, or wax crayon, before painting.

Winsor & Newton Oil Vehicle No. 1

1 I apply the vehicle to my paper.

2 I lay a watercolor wash, and the paint skips where the vehicle is. I drop white acrylic ink into the wet wash, and the ink skips. The skipping action helps to create a sea-foam look.

Press and Lift

Saran Wrap Texture

1 Paint a watercolor ink or acrylic wash ▶ onto your paper. While still wet, place Saran Wrap into the wash. The paint must be wet to create texture. You can direct the design by manipulating the Saran Wrap. If the wash is too wet, you can lift the excess paint with the Saran Wrap and make texture by placing the wrap on a clean surface (or a painting in need of a value change); this is one way of making a transfer. I find Saran Wrap brand works best—it seems to be of a heavier weight than others I've tried.

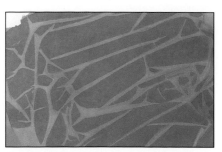

2 When the paint has dried, remove the Saran Wrap. Most often (but not always) the image will be linear. With certain colors and inks you get a shiny surface on your paper, making a nice contrast. Different papers will texture differently.

Waxed Paper

A similar effect can be accomplished by placing waxed paper (I prefer CUT-RITE) into a wet wash. An exciting extra occurs where wax is left on the paper, causing the paint to skip and not completely adhere— very useful for foamy seascapes. For a softer looking texture, remove the waxed paper before the paint is completely dry or use an uncrumpled sheet. A single-edge razor blade is handy for lifting a stuck edge.

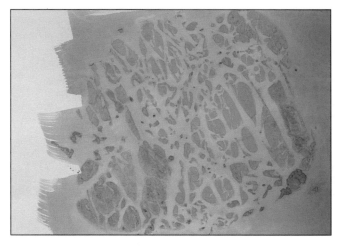

Taped-Line Technique

1 Stick a piece of masking tape on your painting surface. Brush acrylic gloss medium over the tape to prevent paint seeping under the edges.

2 Paint a wash over the tape.

3 When the paint dries, peel off the tape. ▶ Pull it off gently using a finger to hold the tape down as you pull so the tape doesn't rip the surface. BFK Rives watercolor paper is too fragile for this technique.

Toilet Tissue Lift

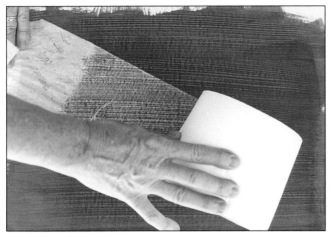

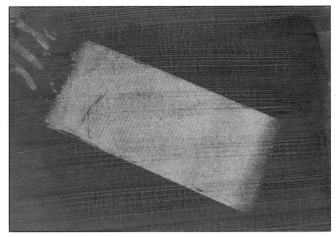

1 Roll out toilet tissue onto a wet acrylic wash. This is a great way to lift excess paint or lighten a passage.

2 An even pattern of paint is lifted. Any texture on the paper transfers to the paint; paper towels are great for this. You can make curves by rolling the paper in waves.

Bubble Pack Texture

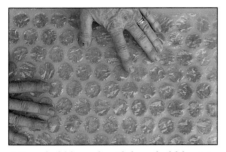

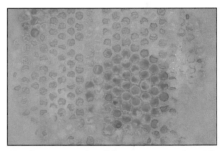

1 Press bubble pack with large bubbles into a wet watercolor wash.

2 When the paint is dry, remove the bubble pack. It leaves a marvelous honeycomb print.

Here's an example of the texture made with bubble pack with smaller bubbles.

String Line

Place a string into a very wet wash. Paint over the string and remove the excess paint (or leave the excess for a watermark halo effect). When dry, lift the string and reveal the print. I love the way this technique works.

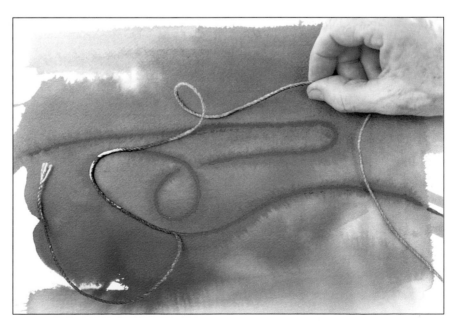

Stencils

Masking Tape Stencil

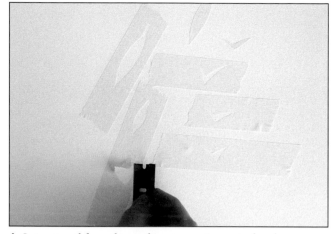

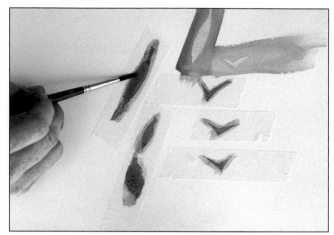

1 Cut a stencil from the masking tape using a single-edge razor blade. Cut gently or you'll cut the paper, too.

2 Paint the exposed shape. I'm using watercolor, but gouache works great.

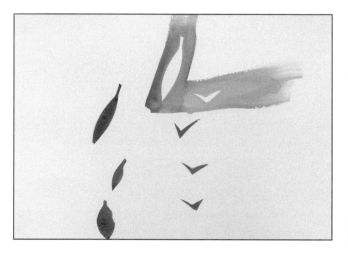

3 Neat trick! If you use opaques, you can place any shape over an underpainting.

Mat Board Straightedge

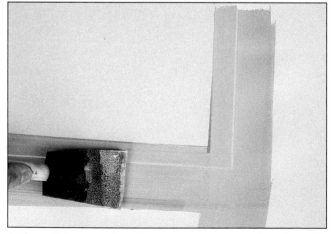

1 Place a leftover mat board scrap on your paper and apply acrylic paint (made opaque with a little gesso). Use a sponge brush for a flat, even coat; a regular brush would allow paint to seep under the board's edge.

2 Remove the board to reveal the straight edge painted on the paper.

Stencil Lifts

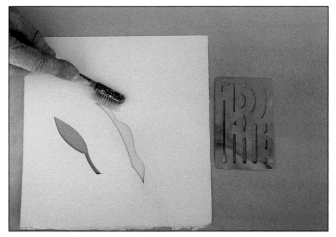 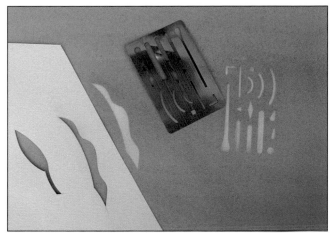

1 Cut a stencil shape out of watercolor paper with a single-edge razor blade (or you could use stencil paper). On a prepared water-color wash, use a toothbrush dipped in clear water to scrub and lift the stencil shape (for fragile paper use a natural sponge). A staining color will not lift to the white surface, but you will see a variation. Acrylic won't lift at all. You can also lift using an erasing shield. Wipe up excess water with a paper towel before lifting.

2 The stencil is moved to reveal the lift. You can use this technique to put a sailboat in water, a seagull in the sky or clothes on a line. The edge is softer than you'd get from liquid mask. The erasing shield is great for lifting little highlights.

Simulated Collage Edge

1 Tear a paper stencil that has a ragged collage-like edge. I love collage, so I some-times like to imitate the look with paint alone.

2 Paint the edge with opaque paint. You can use this technique in either watercolor or acrylic. I used acrylic for this example.

3 Remove the stencil and you have a painted collage-like edge. If I had painted over the entire paper stencil, it would ap-pear I had collaged on a piece of paper.

Prints and Transfers

Sponge Painting

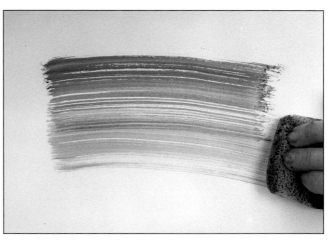

1 Apply watercolor paint to a slightly damp natural sponge and gently sweep across dry paper.

2 I apply a second color and paint next to the first. This is a great way to texture old crocks and vases. A little toothbrush spatter would create a pottery-like texture. It's a good way to render old barn boards, too.

Sponge Printing

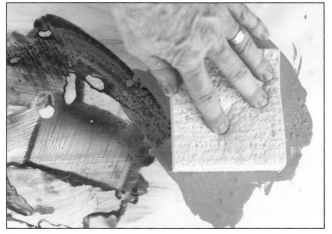

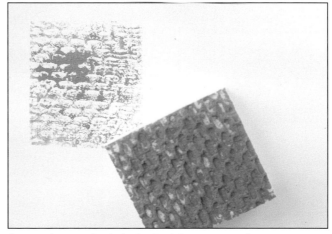

1 Press paint into your sponge.

2 Press down and rub the back of the sponge to leave an imprint.

3 Wouldn't this texture be great for a building or stone wall? Different sponges make different textures. I use natural sponges all the time.

Waxed Paper Transfer

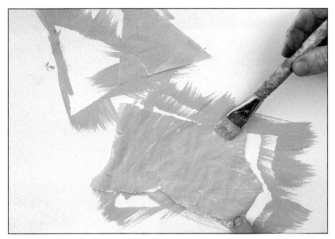

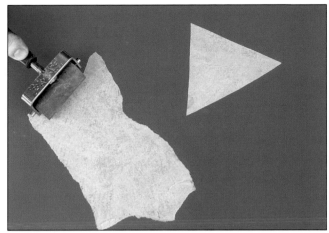

I Cut a shape out of waxed paper and use a flat brush to paint it with an opaque acrylic.

2 Place the painted shape on a prepared surface and apply pressure with a brayer. Wipe up any excess paint immediately before it dries and can't be lifted. You can cut any shape—a ball, bird, flower, etc.

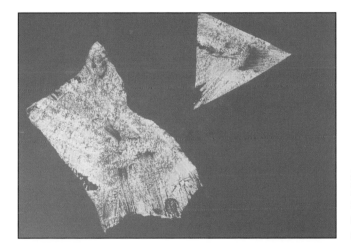

3 When dry (the paint dries fairly quickly), lift the waxed paper shape. The shape is now on your board. For a more solid shape, apply thicker paint. This is great for making color and value changes.

Saran Wrap Transfer

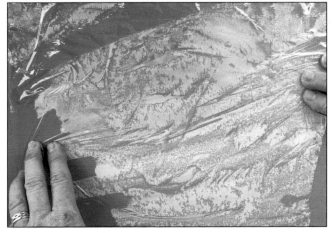

I Paint opaque acrylic onto Saran Wrap and press it onto a painted acrylic or watercolor surface.

2 Remove the Saran Wrap when the paint is dry; the texture transfers to the board. I use this technique for color and value change or to apply paint to a blank surface.

Brayer

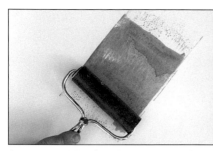

1 Pour a puddle of acrylic paint and roll the brayer in it to pick up the paint.

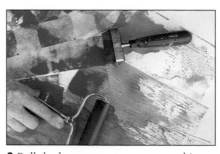

2 Roll the brayer on your paper, making a roller print. Use brayers of different sizes for interesting effects.

3 Brayer prints vary from roll to roll when you use the paint transparently. You have more control with opaque paint, but you don't get the interesting texture.

Paint, Transfer, Print

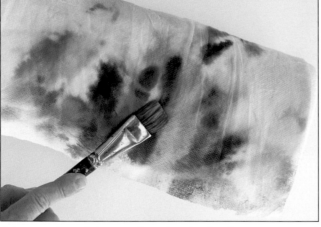

1 As you paint and change color, wipe your brush on a paper towel before going into a new color. This paint is deposited onto the towel.

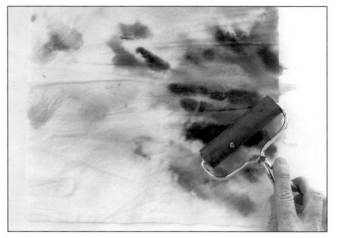

2 While the paint is still wet, place the paper towel on a white surface and roll a brayer over it to transfer the color.

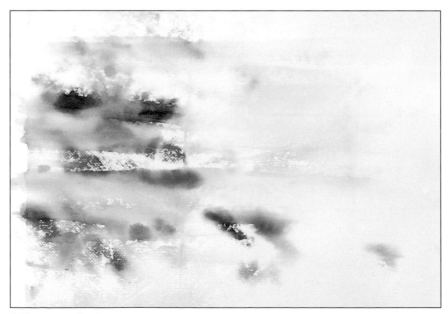

3 The textured print.

Pencil

Pencil Work

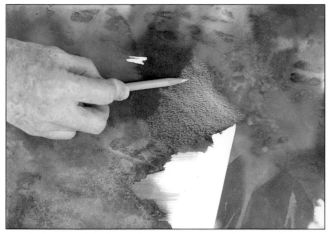

1 Rub the pencil, holding the point sideways (I use Berol Prismacolor pencils). Rub in such a way that the underpainting is allowed to show through.

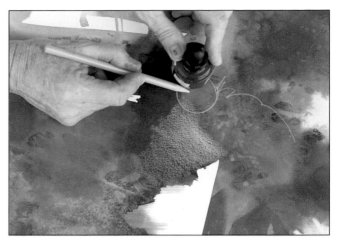

2 I use a jar of ink to make a circle on my painting.

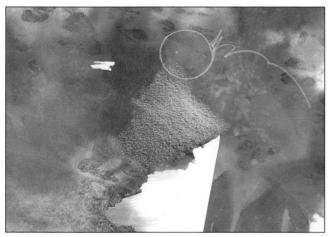

3 The pencil is much easier to use for certain line work, like the circle.

Caran D'Ache Neocolor II Aquarelle Crayons

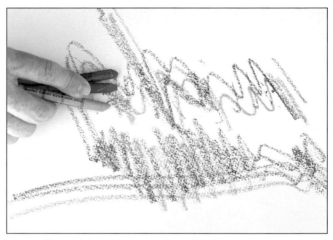

1 Have fun and lay down some free, loose line work with the crayons.

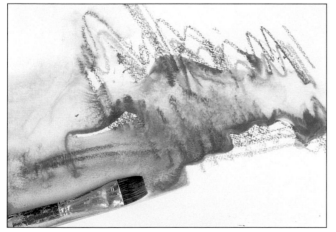

2 Wet the crayons with clear water to activate the crayons.

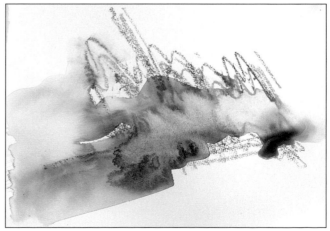

3 Look at the great combination of watercolor wash and line work you get with this technique. These are great for working outdoors.

Filtering

Cheesecloth

1 Manipulate cheesecloth, separating the weave to form interesting patterns for a fabric print.

2 Place the cheesecloth on your surface and brush ink through it—use a lot so the cloth rests in liquid. This will cause a dark mark; brush lightly and the cloth will act like a stencil.

3 Lift the cheesecloth after the ink has dried. This technique works very well with nautical themes.

Facial Tissue Texture

1 Place a dry facial tissue on your paper, then apply watercolor paint through the tissue. Don't use acrylic, or the tissue will be glued down.

2 When the paint is almost dry, remove the tissue. The timing has to be right or the tissue will stick. If it does, rewet the tissue carefully and lift.

Painting Through Rice Paper

1 Assemble your papers and ink, and paint through the rice papers. Rice papers are great to paint or spray through or place in wet washes. They all texture differently. The leftover painted papers can be used in collage work; everything is interrelated.

2 Notice the different finishes. The difference is from the amount of ink and water.

Scraping

Razor Blade

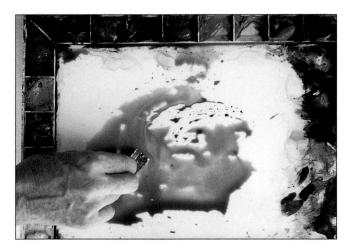

1 Dip your single-edge razor in a paint puddle. I use my paper palette or John Pike palette. A worn blade works better since the surface is not as slick and the paint adheres better.

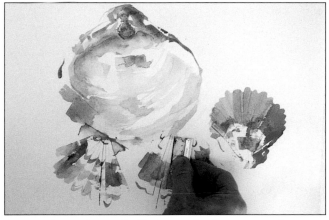

2 Manipulate and twist the blade to make shapes. Many shapes are possible with practice. This technique is great for making trees, sailboats and shell shapes.

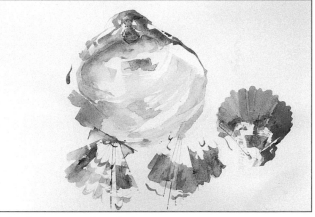

3 The shell start made with the razor.

Brush Handle

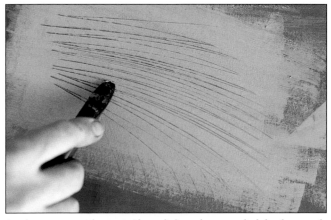

Apply an opaque (gesso and acrylic) wash over a dark background. The slanted end of a 1-inch (25mm) aquarelle brush can be used to scrape through the color revealing the underpainting. You can also scrape out trees, grass and other shapes. This also works in watercolor, but the paint must be nearly dry before scraping or you will get a dark line when pigment settles into the scraped line.

Palette Knife

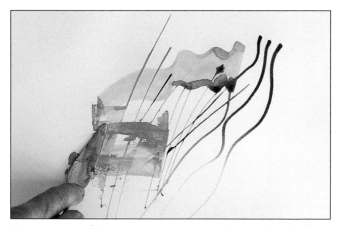

Here are some of the textures you can get using a palette knife. Pick up paint with your palette knife, and apply it with the edge, tip and flat edge. Practice makes perfect.

Texture Close-Ups

Let's look more closely at some of the textures in my paintings. I love texture, but I try not to overdo it. Sometimes I can't believe how fabulous the textures are, and many times they just happen! But I choose to keep them, so they are not merely random happenings; they are conscious choices. I always have quiet areas to balance the textured areas in my paintings. Balance is the key.

Let's look at some finished paintings that have these techniques and textures in them.

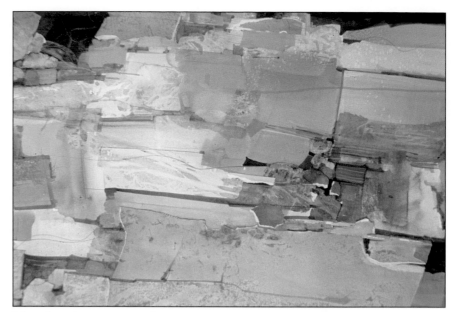

I love the color restraint in this painting. The line work and colors all gently lead you to the center of interest and small cluster of rocks in this ancient wall. The large, quiet areas contrast beautifully with this cluster, set off by a spark of red which complements the greens.

ANCIENT ECHOES
24½″×32½″ (62cm×83cm)
Watercolor, acrylic and collage on BFK Rives printmaking paper
Collection of Mr. and Mrs. Howard Berlin

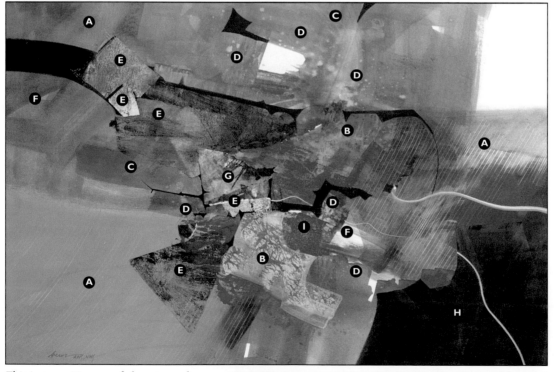

This is an exciting use of almost pure hues. It looks like a color wheel; the primaries and secondaries are all there. The black and white are perfect foils. You can see the complements at work throughout.

CANYON RUN
26″×37″ (66cm×94cm)
Inks, acrylic and collage on paper
Collection of Cynthia Groom Marvin, Esq.

LEGEND

A Comb lines	F Dry brush
B Waxed paper	G Collage piece
C Saran Wrap	H Toilet paper lift
D Bleach	I Spatter
E Waxed paper transfers	

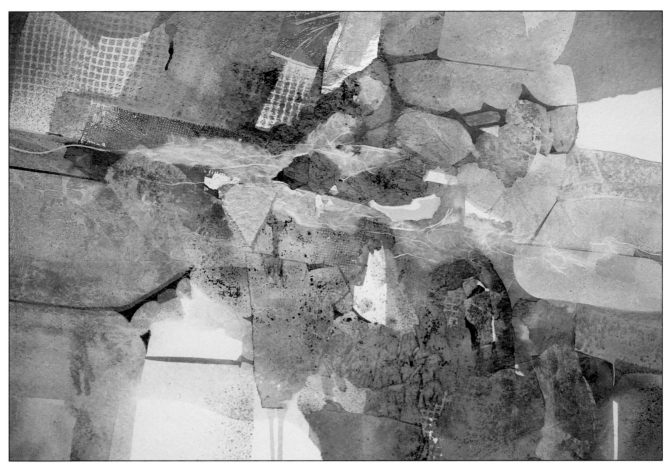

This painting has a clean, crisp look I love. The small areas of warm color contrast with the predominately cool overall feeling. This highly textured piece has many places to look. The geometric grid is a good contrast to the roundness of the rocks.

ROCKS WITH WATER AND GRID
22″×30″ (55.9cm×76.2cm)
Watercolor, ink, acrylic and collage on Arches watercolor paper
Private collection

This is a complex painting. The contrasts of light and dark, quiet and busy, and warm and cool are all used to advantage. The sponge texture adds interest to the quiet areas and works well with the intricate clusters. Everything leads to the center of interest.

CRYSTAL LIGHT
Pat Denman, A.W.S., N.W.S.
22″×30″ (55.9cm×76.2cm)
Watercolor

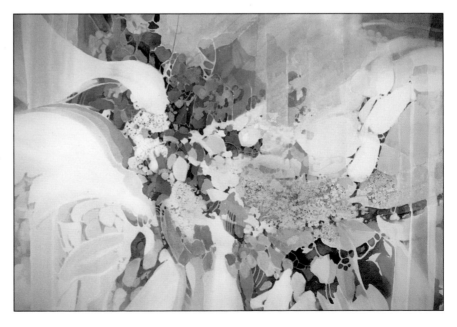

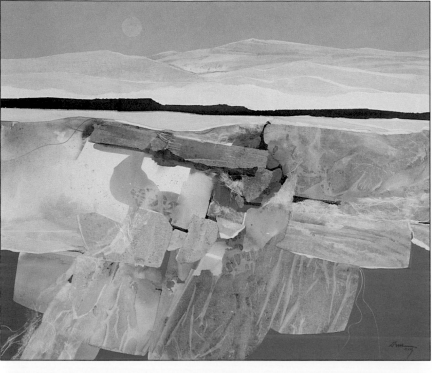

I like the contrast of the flat, collaged hills with the bulk of the rocks below. The dark blue line balances the lighter top with the weightier bottom. The lines of the torn paper repeat the texture of the Saran Wrap used in texturing the rocks. The warm, opaque sky is a good contrast to the cool, transparent rocks. The circular moon shape is the perfect compositional device to give balance to the upper portion of the piece.

FAR HILLS SERIES
26½" × 31" (67cm × 79cm)
Watercolor, acrylic and collage
Collection of Mr. and Mrs. Ward Berlin

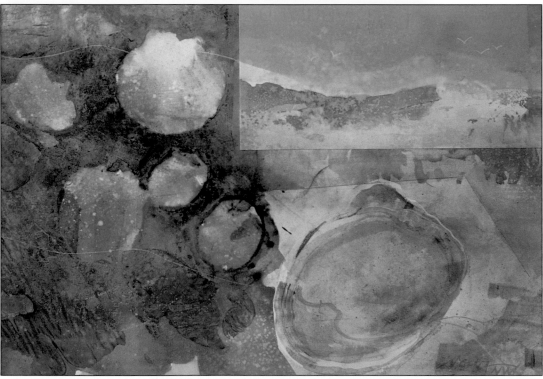

I placed seashells in wet ink and allowed it to dry. When lifted, I was left with a print of the shell outline. I rendered the clamshell with a razor blade and brush. The coolness of the sea and soft spray add contrast to the more solid warm shape that makes up the left portion of the painting. I like the breakup of space, and the large shell and rectangular sea give the proper weight to the darker, more solid shape on the left. It's a matter of balance. The warm, bright pink that cuts the cool right side adds zing to the piece. This imaginary scene tells me all I need to know about the beach, bringing back memories of summer.

SEA SHELLS
15" × 18" (38cm × 46cm)
Watercolor and ink on paper
Private collection

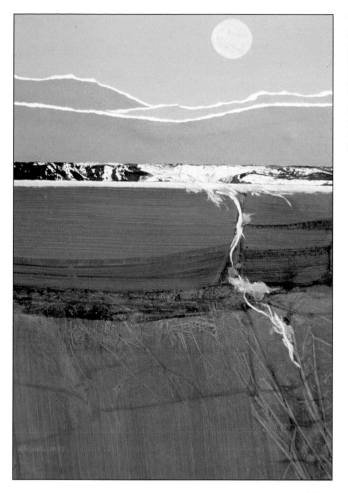

This painting conveys a feeling of serenity. I used Saran Wrap texture for interest. Collage elements were added, and the white lines of the torn paper lend much to the painting. The cool sky adds contrast to this warm painting. I like the simplicity.

FAR HILLS
21½″×29½″ (55cm×75cm)
Watercolor, acrylic and collage
Private collection

This is a totally textured painting. The ▶ fact that it's weeds, neutral and supposed to be old lets me get away with it. The dark spots, which add to the feeling of time, come from heavy alcohol spritzing. I kept this feeling by using fairly cool neutrals with hints of warmth.

WEEDS IN ANTIQUE POT
22″×28½″ (56cm×72cm)
Watercolor, ink, acrylic and collage on BFK Rives printmaking paper

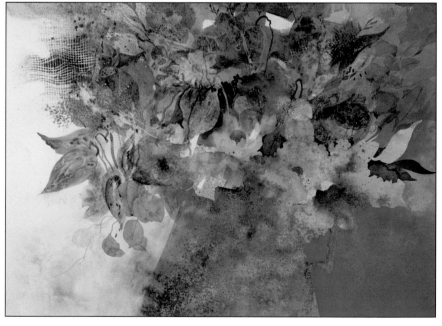

Color and How to Use It

Color is very subjective and can stir emotion. I've noticed that people seem to wear the same colors they paint. Where you live affects your palette. Your mood affects your palette. I am not an expert on color. I don't think you have to be an expert, in the sense that you know and understand the chemical makeup of your supplies, but I do think you need to know the basics. I continuously try to learn more about this subject. Some artists have based an entire career on the study of color. Go to your library and read all you can on the subject. *Exploring Color* by Nita Leland (North Light Books) and *Color in Contemporary Painting* by Charles Le Clair (Watson-Guptill Publications) are extremely helpful.

The Color Wheel

Knowing the color wheel and how colors relate to one another is important. Several color wheels are available for you to buy, or you can make your own. I have and refer to one that Nita Leland created (see page 13). It is good to keep one on hand for reference. There are three primary colors—yellow, red and blue—from which the other hues are mixed. The secondary colors are made by mixing two of the primaries together. Yellow and red make orange; yellow and blue make green, and blue and red make violet. Tertiary colors are a combination of equal parts of a primary and secondary color. Yellow and green make yellow-green, green and blue make blue-green, blue and purple make blue-violet, red and purple make red-violet, red and orange make red-orange, and orange and yellow make yellow-orange. Different quantities of the colors mixed result in different hues.

Points to Consider

• In order to proceed with your painting and bring your work together, it is important to have color dominance and color variation. Vari-

ation is so important. Greens seem to give students the most problems. Don't make all your greens the same. Learn to mix them. As you practice your textures, mix the complements to see the grays you get and mix your greens at the same time.

• Colors opposite each other on the color wheel are complements, and when used together they give excitement to your painting by enhancing and brightening each color. When mixed together, these same colors give you gray. Blue and orange, yellow and violet, and red and green are complements. Use this knowledge to your advantage.

• Bits of pure color next to neutrals or grayed colors will make your painting sing.

• Using colors adjacent on the color wheel—analogous colors—will give

harmony to your painting.

• In order to make a statement, you must know when you want strong color and when you want almost no color.

• You need to understand color value (lightness or darkness) and intensity (brightness or dullness). Good values make a painting. Think light, medium, dark. A good rule is to put the darkest dark next to your lightest light at the center of interest. Remember that colors look different depending on the colors around them.

• You need to have a knowledge of color temperature. Some colors—like red, for example—are warm, and some colors—like blue—are cool. In addition there are cool reds and warm blues. Experiment so you can see which colors come forward and which recede.

I made a hard-edge, soft-edge example of the three primary colors (red, yellow and blue) running and blending together to form the three secondary colors (orange, green and violet).

The Best Way to Learn About Color

The best way I know to learn about color is to try it. You can read about color theory all you want, but you need to use, mix and experiment with color. Just as you can try many techniques on one sheet, you can try many colors. I think trying to create a painting as you're learning makes the learning process more interesting. For me it has always been more interesting than doing squares of color—unless these squares were the painting.

Warm Vs. Cool Color

I suggest you take all the warm colors on your palette and play with them. Put them all down, noticing how they relate to one another, their transparency or opacity and how they mix with each other. Notice how adding a touch of cool color enriches the warms and adds contrast. The cool contrast gives life to your painting. Do the same with the cool colors on your palette and then add a touch of warm color to get the same effect. As you put the colors down, practice your techniques.

Contrast is key to all areas of my work. When you know and understand the basics, you have control and power over your work.

When I go to an art supply store, I buy some colors just because I love them. I am not a purist, and I do use white paint—and black paint. In fact, I use whatever I want. I have warm and cool colors on my watercolor palette. Within each hue I have warm and cool versions. Since I use mixed media, if I don't have a color in one medium, I use color from another.

Learn Color While Practicing Techniques and Textures

As you practice your textures you can also be learning about color. Learning new concepts with one exercise is a time-saver. I start with transparent watercolor and ink and then switch to acrylic for these exercises. Acrylic mixed with gesso becomes opaque, and you can practice waxed paper and Saran tranfers and blocking out your design with quiet areas. After the texture and first layer of color, you can begin to learn glazing and see how one color affects another. You can be creating while learning. And you can't create without getting your hands wet. In this stage you can learn to change value, temperature, dominance. You can begin to see how important color variation is in your work. In these more abstract pieces I use color just for itself—the color and texture are the painting.

Personal Color Choices

The more you practice, the better you get. The more you know how color can work for you, the easier it will be to bring your concept to completion. The more you learn, the more freedom you will have to choose your own colors. I love color, but I also love just a hint of color. I use color many different ways. I try not to have absolutes; I like to have freedom to change. If it looks good, I like it. If it looks good, I keep it. If it looks bad, I change it, and I change it until I do like it. I change a color ten times if necessary. It's really as simple as that. Remember, just because water is blue doesn't mean you have to paint it blue! Think how you can make color work for you. It doesn't matter what color I like—what do you like? Bring your own sensitivities to your work.

This painting makes a statement with its strong use of color. The complements at work here make it even stronger. Whether you like it or not, you have to notice this painting and come closer for a look.

DISTANT SHORE
31"×44" (78.7cm×111.8cm)
Watercolor, acrylic and ink on BFK Rives printmaking paper

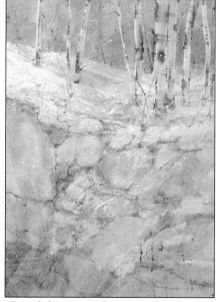

The subtle variety of warm and cool color makes this neutral piece a whisper. I wanted a feeling of the total calm of winter with just a hint of color—not a shout.

WINTER BIRCH
22"×30" (55.9cm×76.2cm)
Watercolor, acrylic and collage on Arches 140-lb. (300 g/m²) cold-pressed watercolor paper
Private collection

This piece is a good example of color dominance. This small painting reads big. When values and color are right, the painting is right.

CANYON SEGMENT
5"×9" (13cm×23cm)
Acrylic and collage on Arches 140-lb. (300 g/m²) cold-pressed watercolor paper
Private collection

Letting Paper Work for You

I have bought and tried many different papers. I will tell you about some that I love and some that are very different. I will not comment on most of the papers I tested. In all fairness to the paper manufacturers and to the readers, who should try all papers and come to their own conclusions, I reserve judgment. It would take another book to judge all the papers. I tried only certain techniques on papers. A paper could be great for other techniques or applications or different paint, but I didn't discover that because of limited testing time. I could suggest not using a certain paper, and it could be the one that could become your favorite or mine.

In a recent workshop, a student was using a particular paper and her work looked fabulous. I rushed to order some and wasn't thrilled. The paint just lay there and didn't move. She knew how to use it, but I didn't really have time to explore all the possibilities.

My absolute favorite papers are BFK Rives 130- and 140-lb. (280 and 300 g/m²) white printmaking paper, and Arches 140- and 260-lb. (300 and 555 g/m²) cold-pressed watercolor paper. I have recently been using 300- and 400-lb. (640 and 850 g/m²) Arches paper as well. I had always thought that the smoother papers, like BFK Rives, would make better texture. But the heavier papers make great texture, too, and they don't need stretching. Dorothy Skeados Ganek uses Arches 140-lb. (300 g/m²) hot-pressed paper (smooth) for her demonstration, and the textures are great. Arches comes in many sizes, and the 140-lb. (300 g/m²) paper is now available in a new sheet size: 16″×20″ (40.6cm×50.8cm).

Arches watercolor paper is an acid-free paper made of 100 percent cotton fibers that make it an incredibly strong and stable sheet. It is mouldmade, air dried and has four deckled edges. Arches watercolor papers are suitable for watercolor, gouache, acrylic, alkyds, oil and ink. BFK Rives is also 100 percent cotton, mouldmade, acid free, buffered and has four deckled edges. It's lighter sizing absorbs the very vivid inks I like to use, so this works to my advantage. Throughout the book are paintings that use these papers, and below is a start that shows one of the effects I particularly like.

Coral Reef paper, 22″×30″ (55.9cm×76.2cm), 100-lb.

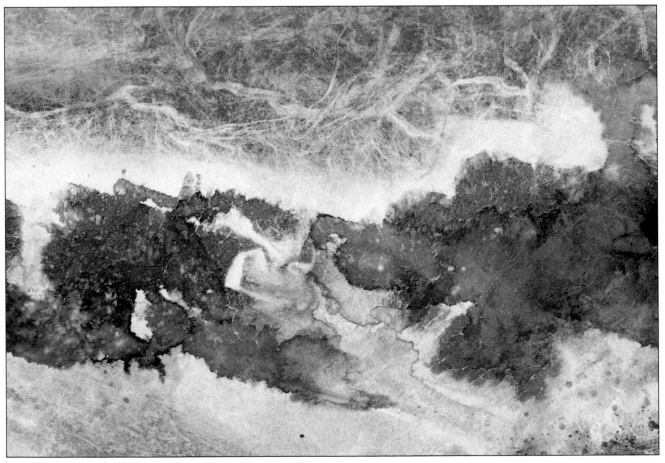

Don't the fibers in Tygerag look like water? This is just a study. I will add white paint to give the wave more definition. The texture of this paper looks very rocklike without using waxed paper or Saran Wrap.

(212 g/m²) has a rough surface and is handmade. Soapsuds are added in the pulp vat; after painting, the bubbles pop and the texture remains. It was great fun to watch the bubbles pop and white spots appear. I think this would be great for a mom with small children. They would just love to sit and wait for the pops and watch the spots appear. This paper could be great for adding textured pieces to collage work and abstracts.

Tara Tygerag paper, 24″×36″ (61cm×91cm), was great to discover, and I plan to use it in the future. It is a graphic art fabric of spun-bonded olefin with acrylic-titanium sizing, and it is for use with all paints, including oil and inks. This is not made from wood pulp, but it looks and acts like paper. The slides on this page show starts using this paper. The texture is great; the fibers are right in the paper, and it doesn't have to be

stretched. Up to a certain point you can wipe off the color and begin again—which is a great advantage—but you have to be pretty quick.

This study on Tygerag shows the wave scrubbed out using a natural sponge. Dr. Ph. Martin's Hydrus paint works great on this surface.

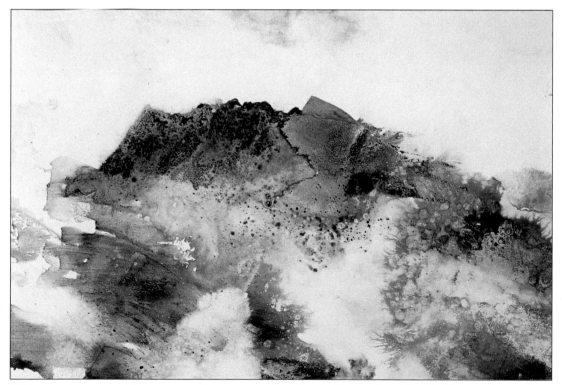

While experimenting with new papers, I tried new paints. On the Tygerag I tried Dr. Ph. Martin's Hydrus Fine Art Watercolors: Sepia, Payne's Gray, Burnt Umber and Burnt Sienna. These colors separate fabulously and form instant rocklike textures. I was so excited. For more information about the Hydrus line, you can reach Salis International, Inc. (Dr. Ph. Martin's) at (800) 843-8293 or Cheap Joe's Art Stuff at (800) 227-2788.

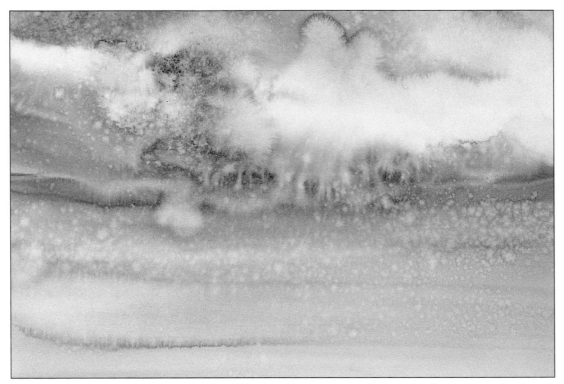

This ten-minute study was done on Strathmore illustration board, high or plate surface, hot-pressed finish. Spritzing with a toothbrush and clear water makes an instant water look. This techniques works well with wet snow scenes, too.

Friends of mine have used it successfully with all types of landscapes. I loved the effect, so I got some. This is why you must look at what other artists are using and doing.

Tygerag worked fantastically with Dr. Ph. Martin's Hydrus Fine Art Watercolors. The paintings on page 67 clearly show the textures you can achieve on this paper. Monoprint worked great with these watercolors on this paper. I painted on one piece of paper and immediately pressed it down on another sheet, and the textures were so rocklike it was amazing. Will I give up waxed paper and Saran Wrap? I don't think so, but I will be doing paintings on Tygerag, and I will be using Hydrus Watercolors.

Strathmore Illustration Board, 100 percent rag, heavyweight, high or plate (smooth) finish, 20″×30″ (50.8cm×76.2cm) is also notable. My friend Pat Lafferty used this paper for painting great seascapes and winter scenes. When you spritz the surface with clear water, you get an instant water look and a wet, snowy winter look. Unbelievable! She showed me how to tear the paper in half. This board is finished on both

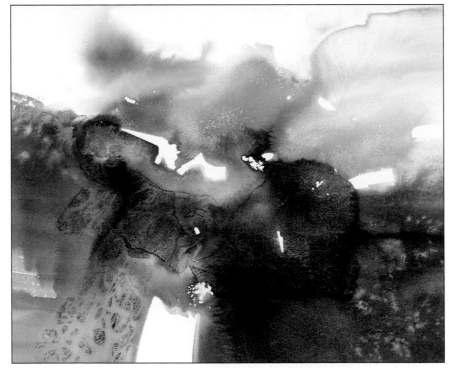

For this study I used Arches 400-lb. (853 g/m²) cold-pressed watercolor paper. I love the textures and particularly the blue edge line to the water spray in the upper right corner. To achieve this, I dropped Indigo ink into a channel of clear water. The water stayed on the surface because of the weight of the paper, and the ink followed the natural flow of the water. I can't wait to finish this study.

sides. You could paint on it the way it is and not have to stretch it, or you tear and stretch. The response of the paint and water on the board is immediate. Get ready for fun!

Morilla #1059 paper makes great textures, is great for getting granulating effects and has great valleys for sedimentary colors to sink into. A special bonus is that it can be separated to look like handmade paper. See *Beach Pebbles* (page 4) for an example of how I use this paper separated for collage.

I now live in Florida and the nearest art supply store of any real interest is 1½ hours away—too far to run to. I usually order by phone. Below is a listing of some of my favorite sources. Chances are, if you live outside a large city, it's hard to get supplies and local stores are more expensive.

• Cheap Joe's Art Stuff [(800) 227-2788] has a great selection of paper samples that you can try before investing a lot of money. They have five different Watercolor Paper Sample Paks offering a total of twenty-four different papers to try. The staff is friendly, and, yes, there is a Joe, and he is accessible.

• Jerry's Artarama [(718) 343-0777] has many unusual papers. When you call, ask for Ilene; she is knowledgeable and eager to help. The Coral Reef and the Tygerag are from this supplier.

• New York Central [(800) 950-6111] has many varieties of paper, and you can buy samples of all of them. They have the Morilla #1059 that I love. White Morilla #1059 is machine-made in the U.S., has a neutral pH, rough surface and no deckles. This 140-lb. (300 g/m²) paper comes in 22″×30″ (55.9cm×76.2cm) sheets and 48″×10 yards (121.9cm×9.1cm) rolls. New York Central has available for purchase swatch books of over one thousand different papers.

Coral Reef is fun, and I think I'll be able to make good use of this paper. All the white dots are bubble pops from the suds added to the paper pulp.

This study shows one of the many reasons BFK Rives is my favorite paper. The spotting in this study is caused by spritzing rubbing alcohol into a wet wash. I love to paint rocks, and this paper works the best of any I've tried with alcohol. These spots are so rocklike; I often use this texture in my paintings.

Format and Paper Size

Changing Your Paper Size

If you only work in one size, start right now to add new sizes to your work. You get too comfortable and familiar when you work in only one size. You tend to make the same painting over and over. You know what works, and you begin to repeat the familiar. You don't want your work to look like a formula. Change adds excitement and prevents boredom.

When you're stuck, you can change your palette or you can change your format. When you work experimentally and crop, you automatically get new sizes. Originally I got my new sizes this way. Now I just start with those sizes. I find that I love small paintings as much as larger paintings. In fact, I sometimes prefer them. There is something precious in small paintings. They are intimate. Presented in an oversized mat they become important.

Challenge of New Design Elements

I particularly like a square format and a long, narrow horizontal. These sizes present certain challenges in design, and I like to be challenged. In fact, I thrive on it. An added bonus to painting these small, different-shaped paintings is that the public likes them too. People can always find a place for a smaller painting if they like your work but don't have much room. People like to make unusual arrangements, and your painting can fit right

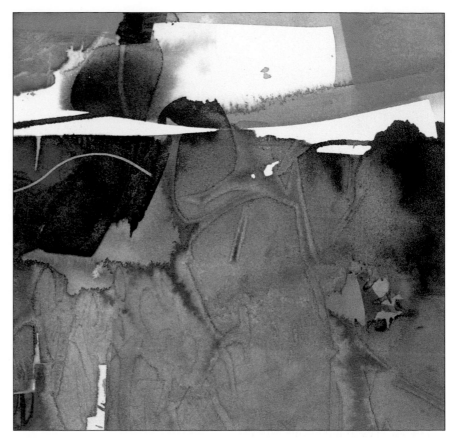

into a collection. From a purely financial point, it makes sense to vary your sizes. I don't paint these sizes just to sell, but as an artist, I always need to buy supplies, and it's important to be aware of the possibilities.

Even though I love to work small, I usually prefer to work large. Of course, the downside is the price factor. Large paper is more expensive to buy, frame and ship. Arches makes paper in sheets of 16″×20″ (40.6cm×50.8cm) all the way up to 40″×60″ (101.6cm×152.4cm). If you've never worked on a piece of 40″×60″ (101.6cm×152.4cm) pa-

This painting is simple and clean. The white line on the left that breaks through the dark is crucial. This white line is the extension of the line on the right, but the color changed.

WATER'S EDGE 25
6¾″×6¾″ (17.2cm×17.2cm)
Ink and acrylic on BFK Rives printmaking paper

per, you have missed the thrill of painting big! My favorite sizes are 29½″×41½″ (74.9cm×105cm) 125-lb. (270 g/m²) and 31½″×47¼″ (80cm×120cm) 140-lb. (300 g/m²) BFK Rives printmaking paper and 25½″×40″ (64.8cm×101.6cm) Arches watercolor paper.

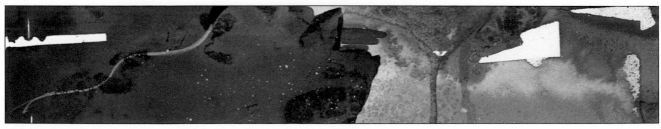

This is a segment from a larger painting. I enhanced the dark left section with a white line to break up the space. I love the contrast between dark and brilliant color.

UNTITLED
2¼″×12″ (5.7cm×30.5cm)
Ink on BFK Rives printmaking paper

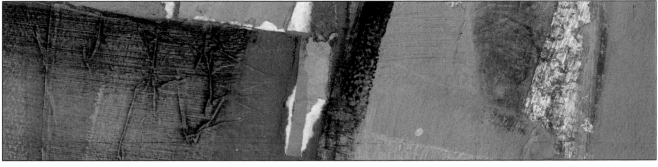

▲ This is also a segment of a larger painting. I added the small touches of orange and metallic paint to enchance the top center portion. I kept this painting for myself. I love to look at it when I'm stuck—it gives me ideas.

UNTITLED
2¼" ×8¾" (5.7cm×22.2cm)
Ink on BFK Rives printmaking paper

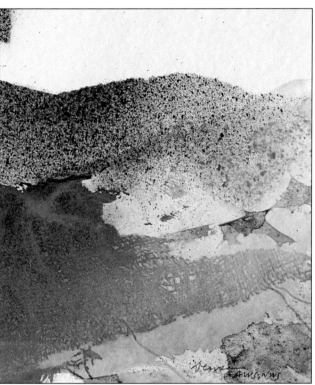

If you love the way watercolor works on smaller sizes of paper, just think of what you can do on a large piece of paper. Can you imagine the impact of brilliant color flowing before your eyes in larger quantities? If you love color and wet-in-wet pours, think of how much more there is to love. It's overwhelming and stimulating. There is great freedom in painting large. Painting large makes me feel as though I am really painting—as if I'm right in the painting. Of course, there are greater challenges in design, but they are worth it. If you are nervous about size, place a sheet of the size you work on now in the center of a larger sheet. Seeing the new paper as additional borders doesn't seem as intimidating as viewing the papers side by side. Try it! Since I work on canvases 48"×60" (121.9cm×152.4cm), large paper seems natural to me. Working on canvas will improve your work on paper, and you will feel more comfortable using large sheets as well.

Think of the last time you went to a watercolor exhibition. If you are like me, you noticed the small paintings and the oversized paintings. In a sea of the more traditional 22"×30" (55.9cm×76.2cm) sheet watercolor paintings, they stood out. They said "look at me."

I used a stencil to spray the hill with a mouth atomizer and placed cheesecloth in a wet wash. The cheesecloth print seems to wrap the hillside. The analogous color scheme and the simplicity of this painting create a harmony.

WRAPPED LANDSCAPE
6" ×7¾" (15cm×20cm)
Watercolor on BFK Rives printmaking paper

USING A PHOTOCOPIER CREATIVELY

It's great to use a copier. I can enlarge photos then enlarge cropped sections of the enlargements. I can find abstract segments in my realistic photos, cut a viewfinder, and enlarge these small segments to form the starts of many abstract pieces. The best part is these copies are black-and-white. It's much more creative for me to make up my own colors than be a slave to those in front of me. I can make copies of my photos, cut and paste and create new images. I then photocopy these paste-ups; it's a great way to test new ideas.

Geometric Shapes to Press and Spray

There are so many geometric shapes you can find and use. Walk through any craft store and see all you can buy. Go to the local lumberyard and get small scraps of wood. Go to an office supply house, where shapes are waiting for you: labels, reinforcements for holes in loose-leaf paper, self-stick removable notes, etc. The supply is endless. Gather all sorts of geometric shapes to have available when you want them.

Compose a painting by spraying through and over these squares, rectangles, circles and triangles. Get shapes in different sizes for variety. Practice color combinations while spraying. See where it leads. Spray grids used for hooking rugs. You can use these grids and other shapes to spray and start a new painting, or you can use opaques to spray these shapes on a prepared background or painting in progress.

These shapes can be placed into wet washes and leave an imprint. You can combine these prints with the sprayed prints for variety. Remember, bubble pack or a penny placed in a wash will give you a circle.

This will start the creativity flowing. Keep working; who knows where it will lead. The next step might be adding geometric shapes to be collaged and creating dimensional pieces. Or you might decide to cut out these shapes to reveal an underpainting. Or you might cut openings to create flaps that can be lifted.

Line work looks great incorporated with these geometric shapes. You might want to get out your pencils and watercolor crayons. A whole new world of possibilities is waiting. You need never be bored again.

Here are some examples to get you thinking and started.

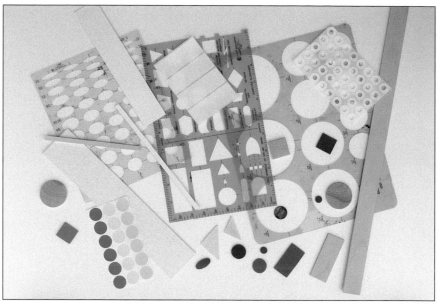

These are just a few of the items I find in arts and crafts stores. There are all kinds of ready-made stencils, labels and geometric shapes you can buy. Others, like the mat board pieces and wood, you buy larger and cut to size yourself.

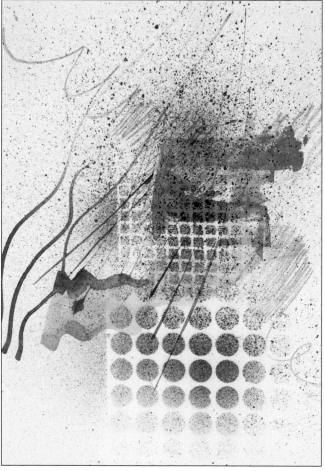

This ten-minute study was done using the mouth atomizer and spraying ink through a grid used for hooking rugs. Circles were made by spraying over felt pads found on the back of frames to protect the wall. I used a palette knife to apply the orange paint and some line work. I got green where orange and blue mixed, and I spattered for texture.

Spray Your Way to New Excitement

There are so many other shapes you can find on walks through craft stores: hearts, stars, birds, flowers, leaves. Anything that strikes your fancy can get the juices flowing. Fabric stores have laces, netting and open-weave materials to spray through. There is cheesecloth and rice paper. Once you begin to look, you'll find lots to spray. It's fun to be on the lookout. Spray one shape and the fear of white paper is gone. This shape may be covered later, but it got you going.

Why not spray stars in an otherwise flat, boring sky? Think of the possibilities. Spray stripes with the stars over a landscape and start an *American Dream* series.

I use prepared stencils to spray through. These can be used in a background as wallpaper for a still life. Leaves could be borders for a fall landscape. Or take a real leaf—birch, for instance. I love to paint birch trees and these birch leaf shapes. The real image could be sprayed right onto the painting.

I spray when all else fails and I'm lost. One sprayed section gets me back on track again. The white wave I sprayed in *Acadia Remembered* (page 127) made the painting and gave me new direction. I spray dead, boring and just plain bad areas to get new, exciting surfaces. I spray for variety and interest and to make color and value changes.

I use a mouth atomizer used for spraying varnish. They're inexpensive and easy to use and clean. I always throw the sprayer in my bucket of water immediately after painting so the tube doesn't clog. Before putting away the atomizer after a painting session, I push water through the tube and look through it to be sure it isn't clogged. Hold the atomizer perpendicular to the bottle of color, making sure you clear the bottom. The paint must be thin enough to blow easily through the tubes; the wider one goes in your mouth and the longer, thinner tube goes in the paint. The atomizer is great to use in small areas, but an airbrush is best for larger spaces—not to mention easier on the lungs!

Here are some of the supplies I use and an example. Get an atomizer and have fun!

This is how you hold the atomizer to spray. It's easier to hold your paper upright on an easel when spraying, but you have to watch for runs and drips—unless you use a thicker acrylic. I spray upright and flat. When you spray flat, remember to keep the jar upright; there is a tendency to tilt the bottle.

The print. The Scotch tape that held the items also made a print. The letter was adhesive, too.

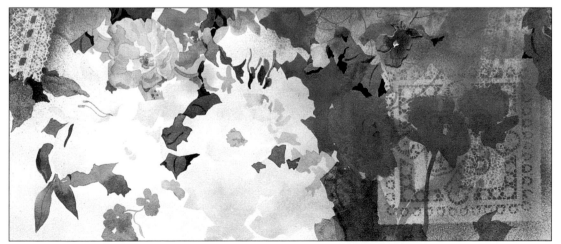

I used a mouth atomizer to spray through lace and a paper doily to create this piece. I sprayed a bronze metallic to fade the flowers and make the painting look old. I added a small collage flower to get a touch of violet.

FADED MEMORIES
11″×28″ (28cm×71cm)
Watercolor, acrylic and collage on BFK Rives printmaking paper

Collage

Collage is great for designing, correcting, finishing and even starting works. I first used collage as a way to correct mistakes. Now I use it for itself. You can learn design from collage. It's always been easier for me to learn by actually doing and seeing. When you place small pieces next to larger pieces or different colors next to each other, you see the relationship change. You learn about shapes, colors, positive and negative space, and composition. You can see, adjust, learn, and it doesn't get glued down until it's right. Collage provides another way to learn while creating a painting.

These small collage studies can be jumping-off points for larger paintings. Collage can fix paintings. Collage makes small gems out of larger paintings that can be cut apart when all else fails and certain sections are too good to throw away. Collage enhances a painting when a slight touch, an added element is needed.

I start a lot of paintings. I start them at demonstrations, workshops and in my studio. The starts most likely to become collages are more experimental pieces which I begin by developing color and texture. These are my more nonobjective abstract pieces. In the course of starting these paintings, I use paper as masks which are cycled into my collages. When I switch to collage, the more abstract starts often become landscapes.

Some paintings are planned as collages. Nothing's more satisfying than getting right to cutting, tearing and gluing. I love everything about it: the mess, textures, the very real feeling of creating a finished painting from many different elements. It's a challenge and keeps up my interest to work in different media.

These are placed flat to photograph and are not glued yet. These are the strips I get when I spray sections. They are used as masks. The sections with the subtle lines were used for practicing drybrush. See how easy it will be to make paintings from your practices? I waste nothing.

This small painting was finished using a cropped segment. I love the texture, spacing and the whites.

▲ This small painting (done in homage to Maxine Masterfield, who let us know that waxed paper should come out of the kitchen) uses inks and acrylic to capture the essence of the sea. I used the rock section and teal section taken from a larger painting, tore a white wave shape and collaged all to a blue sea base. I then signed it the way she does, too. It was the perfect place to sign.

WALK AT THE BEACH WITH MAXINE
3⅓″×6⅓″ (8cm×15cm)
Ink, acrylic and collage on BFK Rives
printmaking paper
Collection of Mr. and Mrs. Nobuko Tomokawa

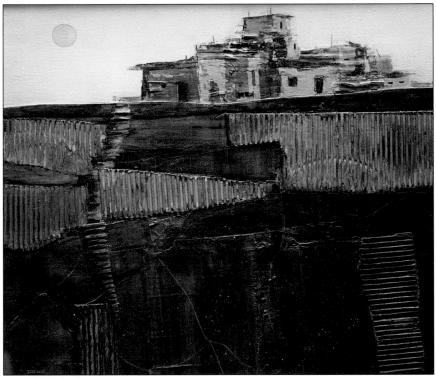

I used corrugated cardboard that was sealed in acrylic, collage papers, gravel and sand to make this collage. To me it says "pueblo dwelling."

PUEBLO DWELLING III
22″×25″ (55.9cm×63.5cm)
Acrylic and collage on Arches watercolor paper
Private collection

1 Collage for Correcting
Sometimes I start out with the intention of using collage. Other times I use it as a way to correct a painting. In this painting the large birch tilts too much to the right and looks awkward. In fact, all the trees slant to the right. To correct this, I will glue and collage paper trees.

2 Tracing Paper
To plan my corrections, I tape tracing paper over my painting. I now draw in the new tree shapes.

3 Saral Transfer Paper
To transfer my drawing to the paper, I place Saral transfer paper between the drawing and my paper. Press lightly to leave a mark.

4 Tearing Tree Shapes
Place a ruler next to my drawn line and tear slowly towards me. Tearing gives the paper a natural edge that blends easily into the painting when glued. BFK Rives 125-lb. (270 g/m²) paper is perfect for tearing.

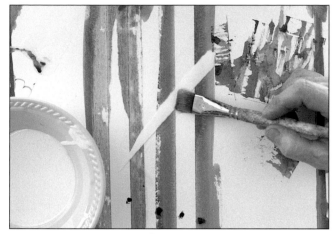

5 Gloss Medium
Liquitex Gloss Medium is used to glue the trees to the painting surface.

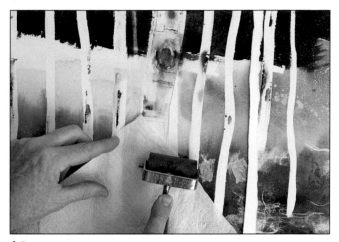

6 Brayer
Press and roll the paper with a brayer. Make sure the collage piece is firmly attached. Place a piece of paper towel or waxed paper over the tree to keep it clean when you use the brayer.

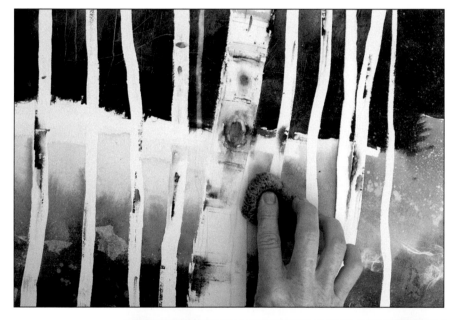

7 Wipe Excess With a Natural Sponge
Wipe up excess glue with a natural sponge. Take care to keep your work pristine. Take pride in every aspect of your work. You should be your harshest critic.

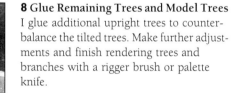

8 Glue Remaining Trees and Model Trees
I glue additional upright trees to counterbalance the tilted trees. Make further adjustments and finish rendering trees and branches with a rigger brush or palette knife.

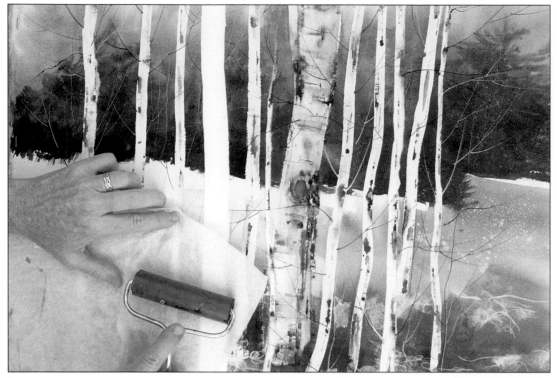

9 Brayer
Press and roll the tree with a brayer, using paper towels to keep it clean.

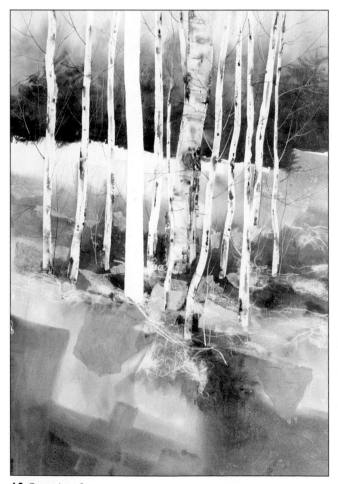

10 Overview 1
This painting looks much better now. The balance is better with the second large tree.

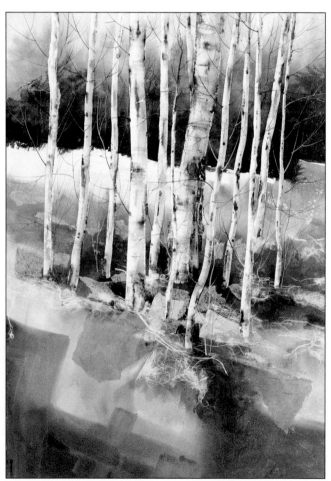

11 Overview 2
The trees are all modeled.

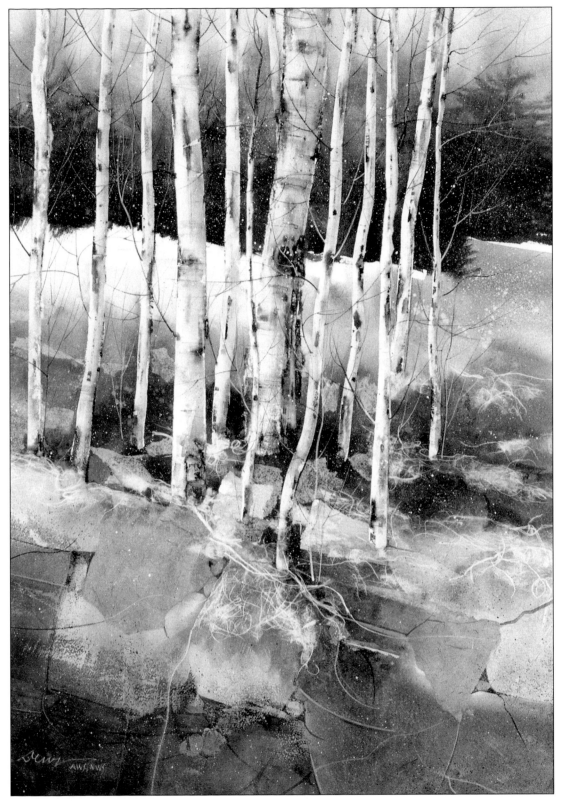

WINTER CLIFF
22″×30″ (55.9cm×76.2cm)
Watercolor and collage on Arches 140-lb. (300 g/m²)
cold-pressed paper
Collection of Cynthia Grooms Marvin, Esq.

Creative Cropping

Periodically I spend the day looking at many starts and listen, hoping they'll speak to me. I always think, if only I finished them as I go, it would be so much more efficient. That's just not my way. I can't tell you how I love to sort through the pile and tear with great abandon paintings earmarked for the collage pile. The rest go in a "to finish" pile or an "I don't know" pile. The "to finish" pile is for starts I would like to finish in the size I began them. The "I don't know" pile is for paintings I'm not ready to tear apart but don't know what to do with them. The paintings in question have great color and texture and could become great finished paintings, but the how eludes me. It's sort of like how I played bridge. If I had thirty-six points or was the "dummy," I knew what to do. In between I was stuck. I gave up bridge, but I've stuck with painting. I'm just not ready to finish some of my paintings. One day when I look again at the pile, the answer will be right there; I just didn't see it before. Be patient; we learn by degrees. If you keep working, the answers will come.

Cropping Is the Key
This cropping technique is at the core of my work. I learn about all the elements of design from this method. It's an integral part of my work and painting process. A great many of my paintings are cropped. It's so standard that, while discussing a painting's problems with my painting friend Eleanor, she said, "Just crop it."

Do I Crop or Not?
I call this tearing method *creative cropping*. In the following sequences I will describe the process of cropping. Basically, I look at every start from every angle and consider the possibilities. I sometimes look through a reducing glass to see a smaller version of the piece (your camera viewfinder is a good substitute if you don't have one). I keep

This is a texture practice sheet. I like to try many techniques and make a painting at the same time. It is the best way to experiment and not become bored. I could finish this as a complete painting at this size, but I will crop it and create smaller paintings. I'll show you how to find four good paintings within this practice sheet.

looking until I decide which view I like most.

How I Crop
If the painting start stands as a whole piece, I stretch it and the finishing begins. If I'm not sure, the painting goes into storage to look at again later. If I decide to crop, I place the painting on the floor and walk around it with different size mats and two mat Ls, looking for good designs. Sometimes an area looks good but overlaps another good area and I must decide which is my favorite. I learn so much about design and color looking within my own paintings and finding designs I would never think of painting.

Cutting and Matting
When I decide which areas are the best, I cut away. It feels great to make decisions, and I really feel I'm making progress. After I finish these smaller paintings, I cut a 4-inch (10.2cm) mat. I want them to be important. I always cut the mat first and then finish. It's easier for me to see the positive and negative shapes within the mat opening.

The Beauty of This Method
The way I work is easy and difficult. The easy part is I never get bored; I

often get great, unexpected results and can correct mistakes. The fact that I can crop allows me to create in a spirit of play and discovery. The starts can be fun. They don't have to be great. It would be nice if they were, but it's not the tragedy it would be if I only worked in transparent watercolor. Never limit yourself to one medium.

The Difficult Part
The hard part is that I often don't have a plan. While this is exciting, it creates problems. I don't feel as organized and I don't finish as quickly as if I concentrated on one discipline. But since I like to really get into the painting process, the changes I have to make are not all that bad for me. I just have to think harder once I begin rather than before. In this method there is always a risk that the surface will become overworked. If this happens, I recoat the surface with gesso and start over, or I get to crop creatively.

Cropped Views
The following sequence is a painting start done as a technique practice sheet that worked better cropped. While I could fix anything eventually and keep the beginning size, I often decide it is easier to crop.

I use L-shaped mats to view and move around the painting to find good design areas. I place the painting on the floor and walk around it. It's good to get some distance. I also view the painting with 6″×6″ (15.2cm×15.2cm), 9″×12″ (22.9cm×30.5cm) and 15″×15″ (38.1cm×38.1cm) mats. I find areas with these precut mats I might not think of making with the L shapes.

In this view you can see the whole painting.

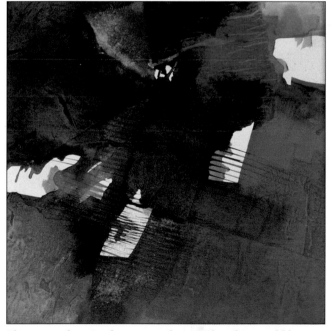

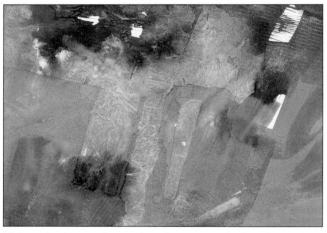

This section is a good start, though not as resolved as the previous example. It has good texture and spacing. I will need to move the blue down and through the painting.

This cropped section has a great design. The whites and blues are in perfect locations to lead you through the painting. Hints of warm color in this predominately cool painting make for good contrast. There are good values and a variety of shapes and sizes in this cropped section. It will not take much to finish this painting.

Capturing Trees, Rocks and Water

Techniques Give Freedom

These demonstrations will show you how to use some of the textures you became familiar with in the beginning of this chapter. Your paintings will grow a step at a time. The more you practice and paint, the better you become. Knowing there are different ways to render a subject gives you great freedom. As you work, remember that paper can be resurfaced with a coat of gesso, you can cover your painting with dark colors and let some of the darks peek out, you can add collage or tear up your paper for your collage box, you can coat your painting with acrylic medium and start again using acrylic, you can crop and make new-sized paintings or you can make lots of tags for gifts. Truly some of my very best paintings have come from total failures. If it's already ruined, go for it! Try anything, experiment and make your own discoveries. Having a mess to work on gives you courage. It's easy to think painting can only get better—and if it gets worse, you've lost nothing.

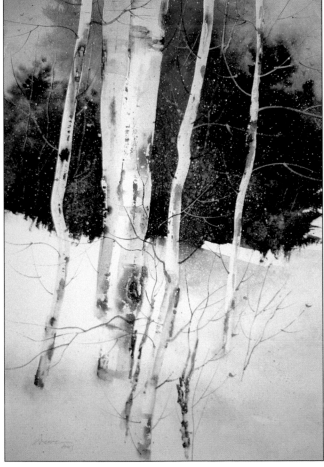

I've painted many birch trees, and this is one of my favorites. I used Dr. Ph. Martin's Radiant Concentrated Watercolor Mahogany and painted pink in the snow to symbolize light. I spritzed this area with bleach to get sparkles of light and used liquid frisket to mask out the trees.

BIRCH LIGHT
11″×14″ (28cm×36cm)
Watercolor and ink on 140-lb. (300 g/m²) Arches paper
Private collection

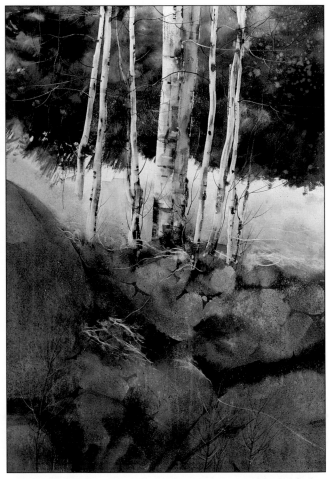

I used a fan brush to paint the background trees and liquid frisket to mask out the birch trees. Saran Wrap, waxed paper, alcohol and rice paper were used for texture.

WINTER LIGHT 6
21″×29½″ (53.3cm×74.9cm)
Watercolor on BFK Rives 125-lb. (270 g/m²) paper,
rice paper collage

Paper

I used various papers for these demonstrations. I only specify the paper if it's germane to the particular technique. You should try many different papers, too, so you see what works best for you and because different papers work differently. I think it limits you to have me say what paper you should use. Part of becoming a better painter is to try new things. When I tear up a piece of paper and discard it, believe me, I've tried everything!

My more abstract paintings look abstract because I use nontraditional color. Remember that water, trees and rocks can be red, purple or green. You are the painter. You get to decide. In abstract work you can give a clue to your subject in the title. If the title is *Sea Breeze*, the viewer knows your purple, pink and orange wave is indeed a wave, and the viewer gets a new perspective.

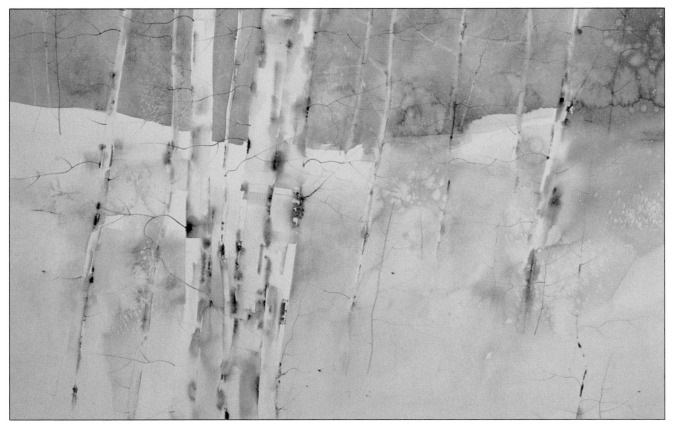

I didn't use frisket for these birches; I painted the area around them, leaving a negative space. I used a razor for modeling the trees, salt for texture and clean water spatters for watermarks. The textures make it really seem like fresh snow to me.

BIRCH ESSENCE
25½″×40″ (64.8cm×101.6cm)
Watercolor on 260-lb. (555 g/m²) cold-pressed
Arches paper
Private collection

Trees

Realize a Tree Through Spray Painting

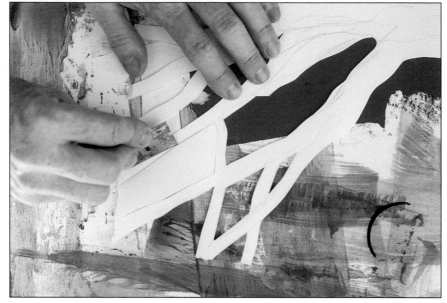

1 Cut a Template
Draw a tree to cut for your template. We have great live oak trees right outside the door. I grabbed a pencil and made a sketch.

2 Prepare a Background
This background was painted using a 2-inch (51mm) Robert Simmons Skyflow and Winsor & Newton Artists' Water Colours Cerulean Blue, Burnt Sienna, Alizarin Crimson, Raw Sienna and Sap Green. Feel free to choose any color you like.

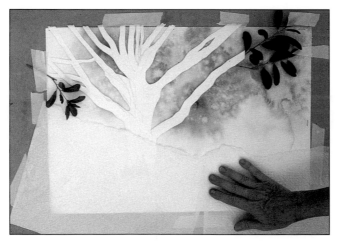

3 Position Tree and Leaf Templates
Tape your templates in place over the background. Instead of artificial leaves, I use real oak leaves.

Know Your Subject

You can always take a brush and paint what you see in a more traditional manner. Even when I worked more realistically, I still used my natural sponge for texture and forming waves. The more you teach yourself, the more you look and really observe. Your study of the subject will show in your work. Everywhere I go, I take pictures of what I like to paint. I am familiar with these subjects. I have painted sitting on rocks; I have painted until the water was at my feet. Trees are all around, and now that I'm living in Florida, I'm sure palm trees are in my future. I use photos as references, but I try to capture the essence. One of my favorite paintings is *Acadia Remembered* (page 127). To me, this is the essence of the rocks and the water and the Maine coast I love. When I get a painting like this, I know I've captured what I feel. This painting is not one particular group of rocks in Maine; it's all rocks.

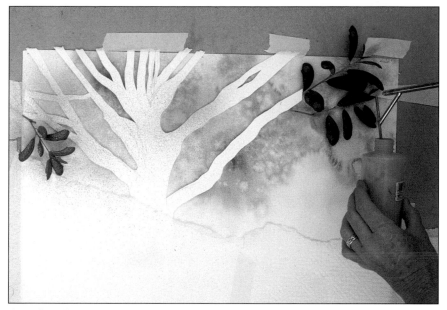

4 Mask and Spray
Place a paper towel mask over the bottom portion of the paper. I use a mouth atomizer to spray FW Indian Yellow Acrylic Ink over the tree and leaves.

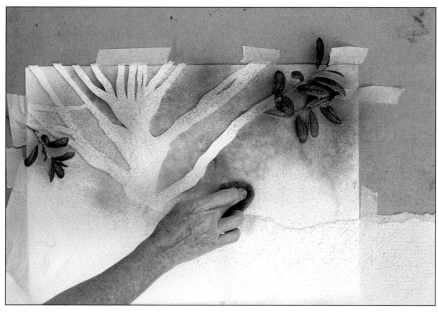

5 Clean Any Drips
Gently tap with a natural sponge to catch any drips.

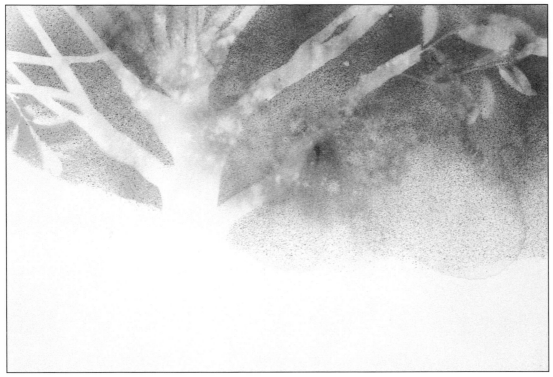

6 Overall View
I just love it like this, but I decide to show more of the tree trunk
so it's firmly rooted.

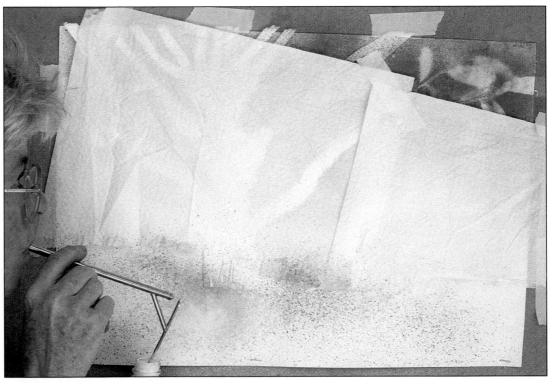

7 Mask and Spray
Mask the top portion with paper towel and spray away. First I use
FW Olive Green Acrylic Ink because I'm thinking grass. I hate it!
I immediately remask and spray yellow over it. I loved it on top;
why not the bottom, too?

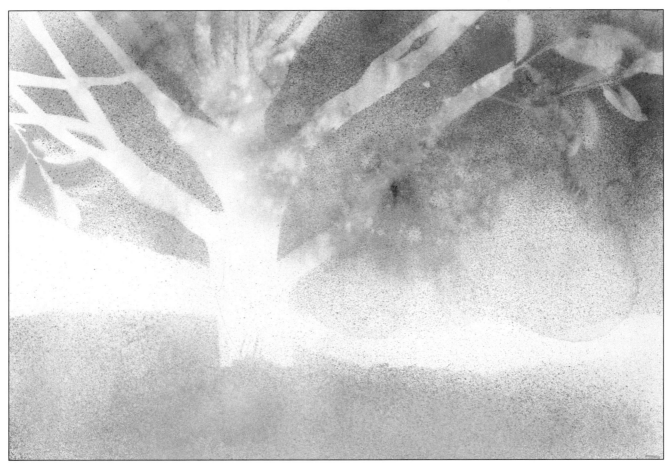

8 Overall View
I study what I have so far. I'm not quite finished. I think I should have used violet or left more white or made it multicolored to give an impression of flowers. At least you know it's a tree. I'll continue to work with it another day.

Rocks

I love to paint water, rocks and trees, and I hate to be bored. In order to keep up my interest, vary my paintings and help me find solutions for different starts, I try to capture these subjects in different ways. When I first started painting, I used my brush and painted what I saw—what was there. I now pour, spray, lift, scrub, print and paint with water, alcohol, a razor and a natural sponge as quickly as I can—and I still use a brush.

Brayer and Template

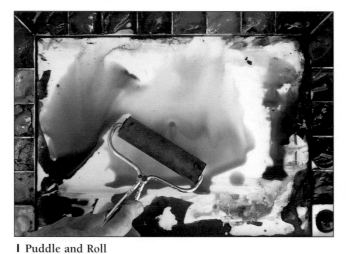

1 Puddle and Roll
Make a puddle of Winsor & Newton Ultramarine Blue, Burnt Sienna, Antwerp Blue and Raw Sienna paint in your palette. Roll a brayer in the paint.

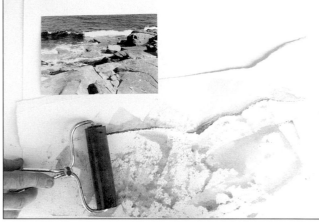

2 Tear a Template
Tear a template in the shape of a rock to roll the brayer over. The brayer marks closely resemble the rock I'm using for reference.

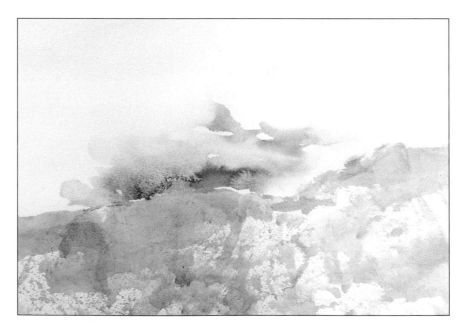

3 Overall View
I add a touch of water so that further reference is given to the markings. A few lines and a dark value are all that's needed to finish these rocks.

Razor Blade

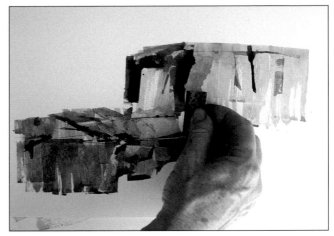

1 Mix Your Paint
Mix Ultramarine Blue and Burnt Sienna in your palette, then pick up paint with your razor edge. A used blade works best.

2 Apply the Paint
Apply paint and make lines with the flat side of the razor. Use the edge point to carve out highlights. Just like when you use a brush, twist and turn, lift up and press down. It's all in the wrist and hand movement.

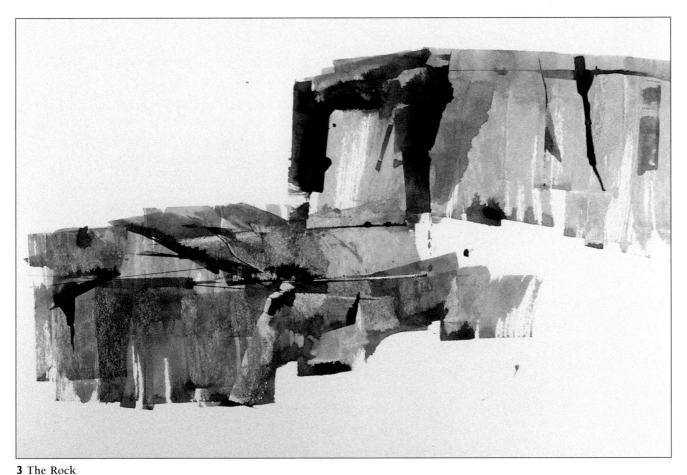

3 The Rock
All of this rock start was done with a razor. Pretty sharp! (No pun intended.)

Tape and Spatter

If the shapes are wrong, you need to develop an understanding of why they look wrong. Keep working until they look right. Become your own teacher. That is where success lies.

1 Masking Tape
Place masking tape on the paper and cut out a rock shape with a razor blade. Cut gently so you only cut through the tape and not the paper.

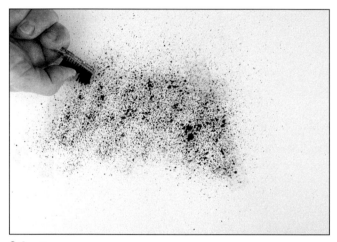

2 Spatter
Spatter paint with a toothbrush. You could also use a mouth atomizer.

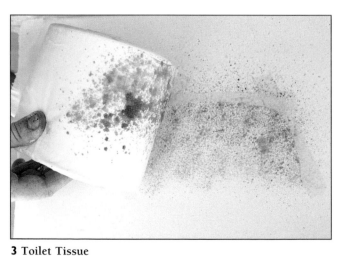

3 Toilet Tissue
Roll off excess paint with a roll of toilet tissue.

90

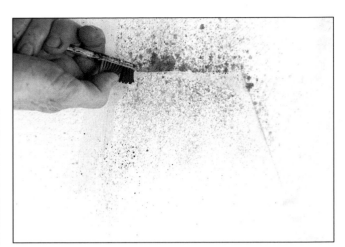

4 The Rock Print
Don't do this. I forgot to mask properly, so I've spattered where I shouldn't have.

Step 2 should have been masked with paper towel like this before spattering.

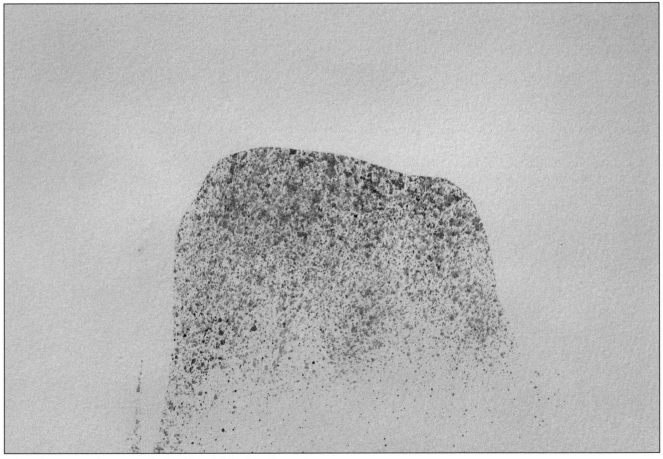

When done properly your rock should look like this. This rock is pink, but it could have been purple or orange. It's your rock—it can be any color.

Paper and Paint Transfer

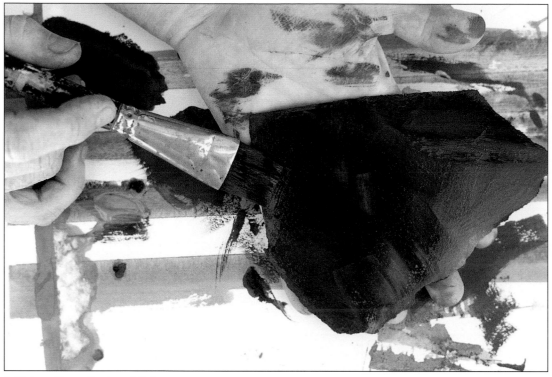

1 Make a Paper Rock and Paint
Tear scrap paper into a rock shape. Hold it in your palm to paint (to prevent fingerprints).
I use gouache because of its consistency. It doesn't matter with this approach if the paint
lifts when you model it. It all adds to the textured rock.

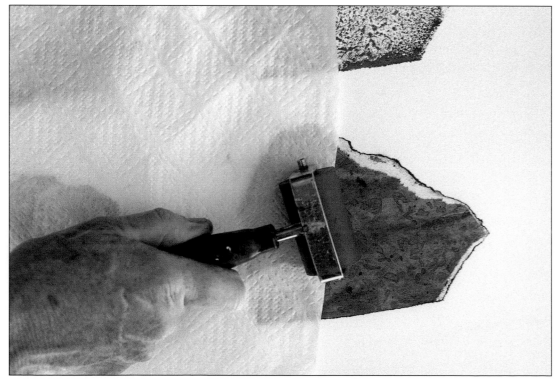

2 Brayer
Carefully place the painted rock face down. Roll the brayer back and forth gently. Place a
paper towel over the paper rock to pick up any excess paint.

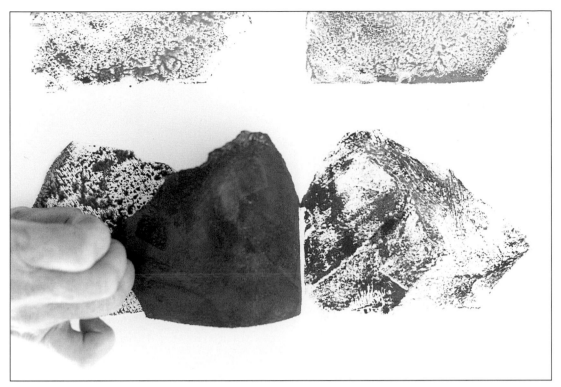

3 Lift the Paper Rock
Gently lift the paper rock. Try not to drop it, or you'll have a print where you don't want one.

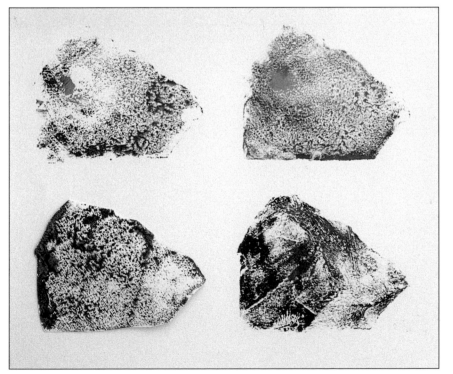

4 Prints
1. Top left: Ghost print (second print) made from the paper rock used in step 2. This is a better print. There's more variety than in step 2, and the gold color does not look like a blob.
2. Top right: The gold paint was too thick, and it looks poor in the print.
3. Bottom left: Different papers print differently. Look closely and see the lines made using Fabriano Artistico 140-lb. (300 g/m^2) cold-pressed watercolor paper. It would be good to remember this if you were painting barn siding.
4. Bottom right: A pretty good print. It really looks like a rock.

Water

Waves From Wax Resist

1 Paint With Paraffin
Rub paraffin over the paper surface. This will act as a resist.

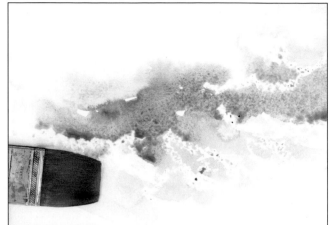

2 Paint
Using a 2-inch (51mm) Robert Simmons Skyflow brush, I sweep Winsor & Newton Cyanine Blue and Raw Sienna over the wax. Wherever the paint touches the wax, it resists.

3 Overall View
With just wax, two colors and watermarks, the texture from the resist says "water" to me. Put in a seagull and it could be finished.

Stencil and Spray a White Acrylic Wave

1 Painting Start
Start a painting with rocks and water in mind.

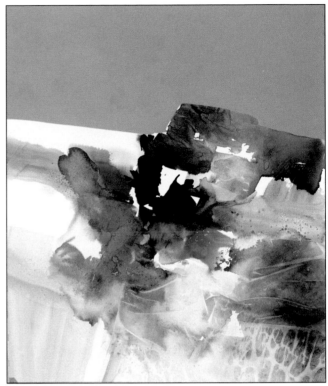

2 Backdrop for Wave
Using Liquitex acrylics Phthalocyanine Blue and Burnt Sienna and gesso, paint a background that could be sky or water. This will be the foil for the wave. Gesso makes a handsome, flat look.

3 Make a Sketch for a Stencil
Use acetate to draw and plan a wave shape.

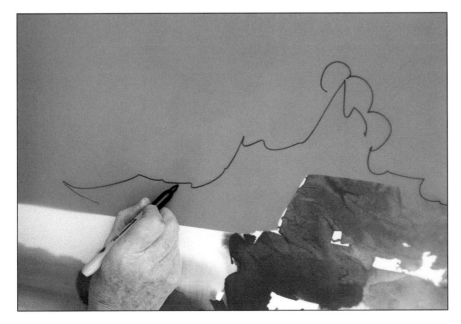

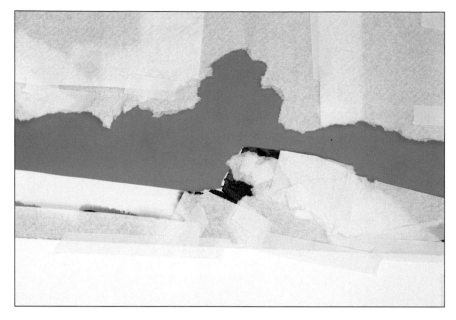

4 Cut a Mask or Stencil
Cut out the wave shape to use as a guide for making a mask. I recommend a paper towel because it's easy to shape, and it absorbs the overspray.

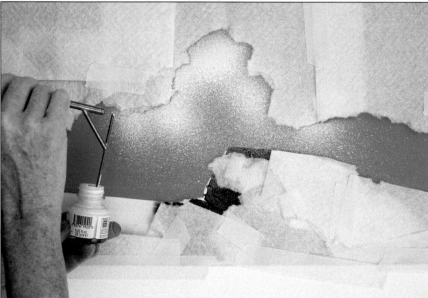

5 Spray
Spray the wave with FW White Acrylic Ink.

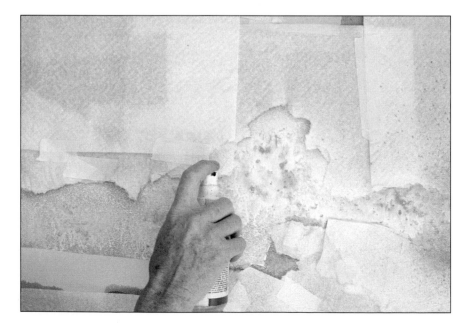

6 Alcohol, Natural Sponge
Quickly manipulate the wave shape with alcohol and a natural sponge to get the look you want. You have to experience this for yourself. I know it's ready when it looks right to me. Sometimes I do this over ten times.

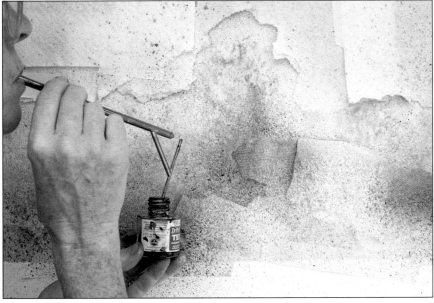

7 Spray
Spray diluted Indigo Ink and Antelope to model the wave. Where the inks mix, they form green.

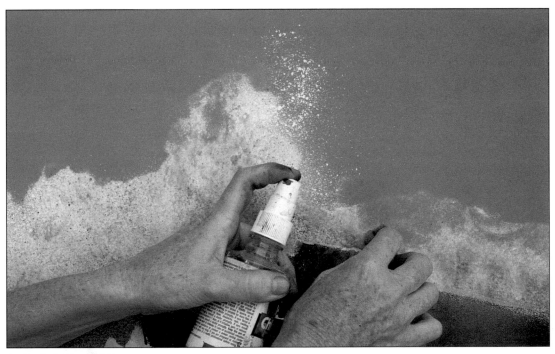

8 Alcohol, Natural Sponge
Spray alcohol again and manipulate the wave with your natural sponge. Alcohol lifts dry acrylic; if you rub too hard or long, you may lift the underpainting.

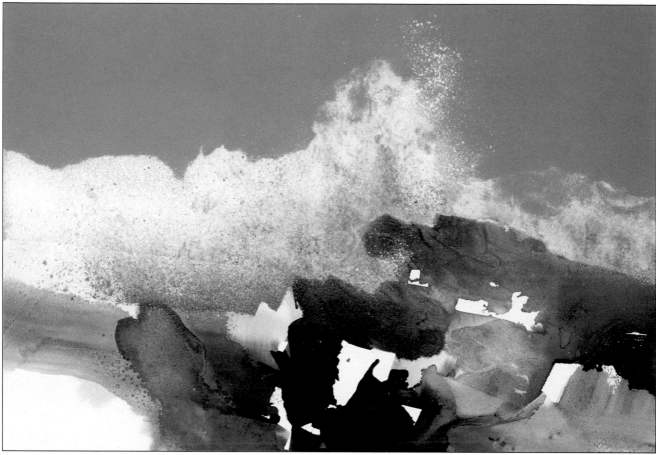

9 The Wave
When I finish this painting, I will adjust the
wave more and make additional rocks jut
into it.

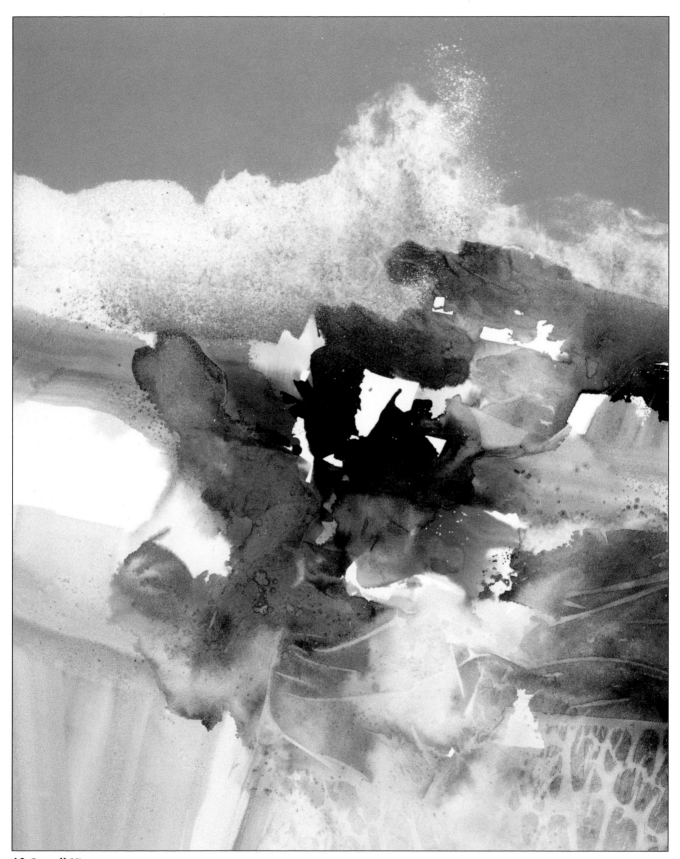

10 Overall View
This is a great painting start, but for me this has many more steps before it will be finished.

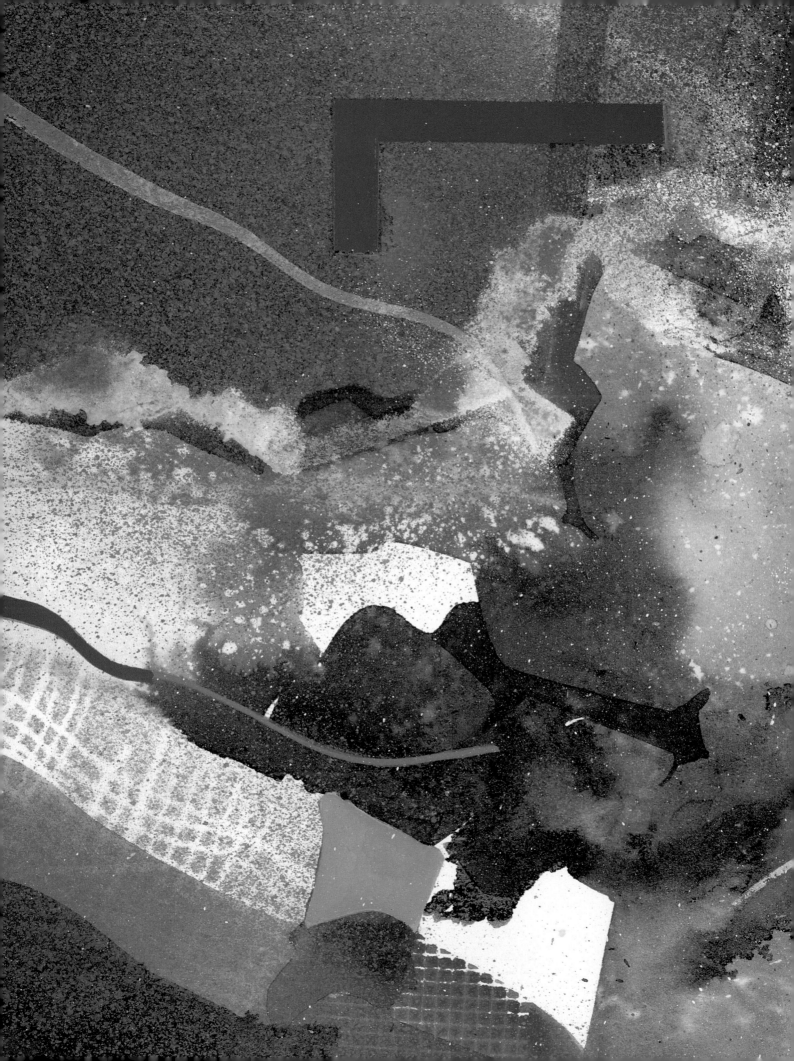

One Start, Three Finishes

A WALK THROUGH MONTAUK WITH RICHARD AND HANS 4,
for Baby and Bluey
10¾″×14¼″ (27.3cm×36.2cm)
Watercolor, acrylic and ink on BFK Rives printmaking paper
Collection of Kumiko and Joseph Dews

Every start has many different possible finishes. If twenty people in a workshop all began with the same start, there would be twenty different finishes. We are all different, and we all bring everything that is uniquely us to the task. This is as it should be. Be yourself, not someone else.

Go With Your Concept

Never waste time worrying that you're doing a painting the "right way." There is no "right way." You have a vision and even if you change it twenty times before you finish, the current vision is exactly what you should be doing.

Develop Your Ideas

In these finishes I use many of the textures we've explored in the previous chapters. The following demonstrations should make them clearer for you. By doing different versions, no one image becomes too precious and you can give free rein to all your ideas. Each painting will lead to another idea, and the best one is always just around the corner. That's why we keep painting. Look at these demonstrations and see how I arrive at my finishes, then duplicate my start and try your own finishes. I think, however, you should try your own start rather than mine. Then copy it ten times and finish it ten different ways. You'll never again have to say, "What can I paint?"

FINISH #I

Materials List

Winsor & Newton Water Colours:

Alizarin Crimson

Cerulean Blue

Burnt Sienna

Raw Sienna

Ultramarine Blue

FW Drawing Ink

Turquoise

Dr. Ph. Martin's:

Antelope Drawing Ink

Mahogany Radiant Concentrated Watercolor (not lightfast)

Liquitex Acrylics:

Phthalocyanine Blue

Burnt Sienna

Raw Sienna

Brushes:

1-inch (25mm) flat

rigger

toothbrush

no. 4 round

Texture Materials:

Alcohol

Diluted bleach

Drywall crack tape

Mouth atomizer

Natural sponge

Plastic mesh bag

Saran Wrap

Waxed paper

Additional Materials:

Acetate

Construction paper

Liquitex gesso

Palette knife

Paper towel

Scotch tape

Stencil (watercolor paper)

▌Choose a Simple Start

Begin by choosing or painting a start with simple shapes and textures you can duplicate easily. For mine I wanted soft and hard edges, a variety of shapes and texture and light, medium and dark values and a neutral color to balance the vibrant inks. I painted this start flat on my painting table; you can paint yours any way that's best for you.

2 Choose Your Subject

View your start from every angle for inspiration. I put my painting upright on an easel and view it with a mat. Viewing the painting upside down inspires me. That white shape between the neutral color and the bleach texture would be a perfect spot to render birch trees. The trees were painted with a palette knife and rigger using Winsor & Newton Ultramarine Blue and Burnt Sienna. I'm tempted to leave a lot of white, but the painting slopes to the right, the Mahogany lump in the center is odd, and two square shapes are hanging in air.

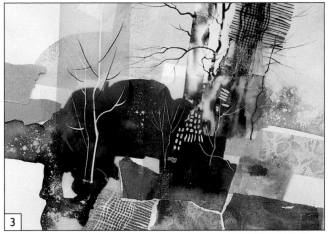

3 Use Diverse Elements for Further Planning

Any item has potential for shaping your painting. I try color movement and shape arrangement by placing colored papers on my painting, paint on an acetate overlay to see what more trees might look like, and tape on the plastic mesh bag to see how its texture will look. I decide to paint upright on an easel from this point on.

4 Spray

The bag texture looks good, so I mask and spray.

5 Make a Stencil and Lift

I want a tree on the left side of the painting to balance the right stand of trees. I use water and a toothbrush to lift in the neutral watercolor area.

6 Bleach Lift

Using a rigger I lift two trees and branches. Remember, you need proper ventilation when using bleach. Clearly label your jar, and keep it out of the reach of children.

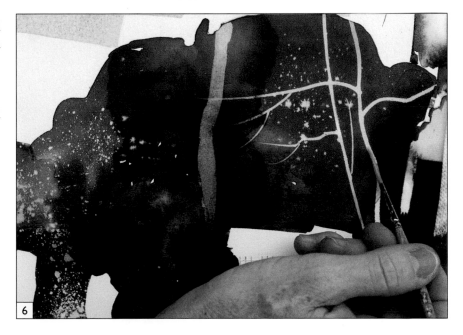

7 Adding Rocks

I paint in rocks with Winsor & Newton Raw Sienna and then texture with waxed paper torn into rock shapes, crumpled and placed in the wet paint. I immediately place Saran Wrap over the waxed paper for additional texturing.

8 Overview

It's starting to come together. You put the painting together one step at a time. The painting still slopes to the right, and I don't like the white shape on the right. I also need to add neutral color someplace else for color movement, and I need to make the Mahogany lump less obvious.

9 Keep on Painting

I paint another rock on the right and slope it upward. I use Mahogany and a waxed paper transfer using Phthalocyanine Blue, Burnt Sienna and gesso to make a color change (see texture mini-demonstrations in chapter two). To move my color through the painting, I add a similar rock across from the first. I leave white spaces for two trees and add yet another rock and paint over the drywall crack tape with FW Turquoise ink. I don't like having the bag and grid textures together—especially the same color. I'll break it up with Raw Sienna and Antelope. What was I thinking?

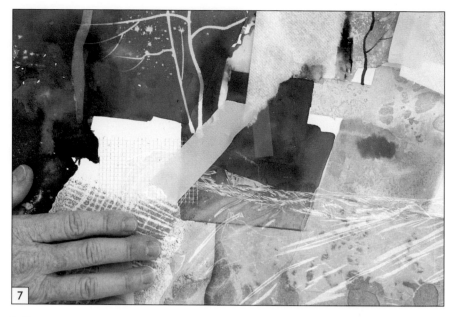

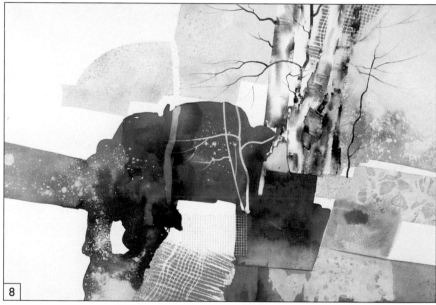

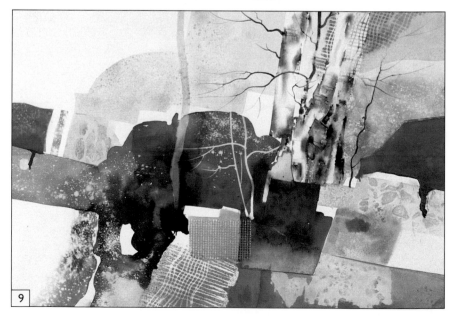

10 Make a Wax Transfer
I close the white space and eliminate the downward slope by bringing a rock up into the Mahogany rock using a waxed paper transfer. Taping the waxed paper to my painting, I draw a shape that will be cut out for the transfer.

11 Paint and Brayer
I place the waxed paper down and paint with a mixture of Liquitex Acrylic Raw Sienna, gesso and Phthalocyanine Blue. The gesso makes the mixture easier to paint on the waxed paper. The paint will skip on the wax. You need to paint a few times until it starts to stick.

12 Lift the Waxed Paper
After the paint has dried, remove the waxed paper. Drying varies with the fluidity of the paint. Check and don't wait too long or it could be hard to remove. It doesn't take long to dry.

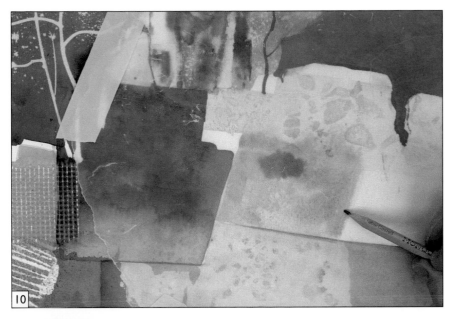

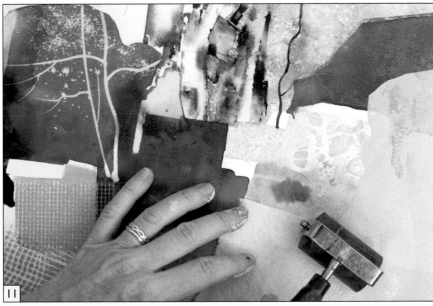

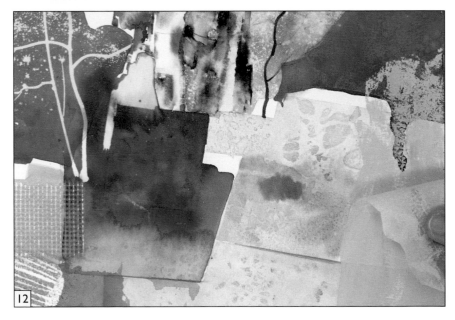

13 Overview
There's a lot left to do on this one. The rock on the left is too dark. There's a brown blob in the Raw Sienna square to be taken out. The birch trees should break into the Mahogany square. The color used in the waxed paper transfer doesn't look intergrated. The top left is boring; not to mention, I won't be adding two trees where I left the white spaces!

14 Saran Wrap Transfer
I repeat the transfer with the same paint mixture used for the wax transfer to better integrate the color into the painting.

15 Bridge the Gap Between the Trees
With a no. 4 round I use my favorite mixture (Liquitex Phthalocyanine Blue, Burnt Sienna acrylic and gesso) and paint a connection between the Mahogany rocks.

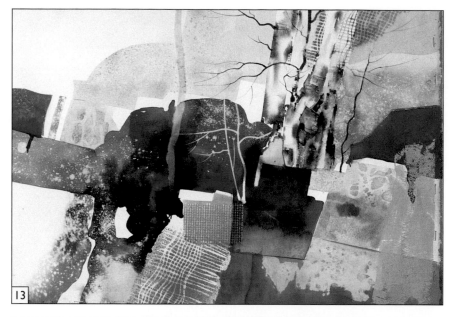

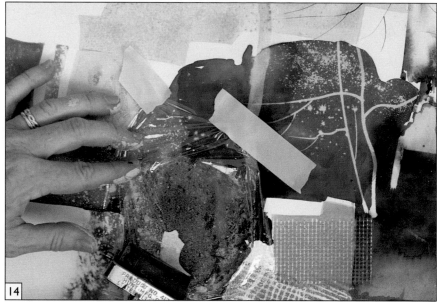

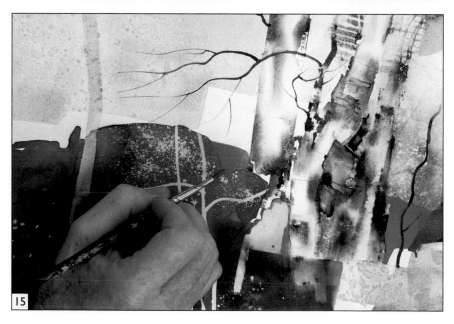

16 Overview
I change value on the left rocks, move the texture from the plastic mesh bag over and finish the trees. I like the bridge of color connecting the Mahogany rocks.

17 Spray, Waxed Paper Transfer, Paint
I spray again through the bag with a darker value. I use white to spray over the rocks and a waxed paper transfer on the rocks. The tree branches are rendered with a rigger and Winsor & Newton Ultramarine Blue and Burnt Sienna watercolor and Turquoise ink for the branches on the gold tree. Over the Turquoise bag spray (bottom center), I use a 1-inch (25mm) flat and gesso to lighten the color value. Raw Sienna mixed with gesso, dabbed on with a natural sponge, integrates the neutral area with the rock color. I still need to change the color of the drywall crack tape and darken the value of the Turquoise exit branch line on the gold tree.

18 Make Color Adjustments
I wanted to change the drywall crack tape texture with Raw Sienna, but collage paper showed me Mahogany would be better. I paint it and press Saran Wrap into the wet wash.

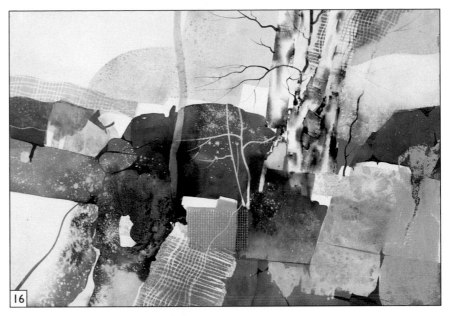

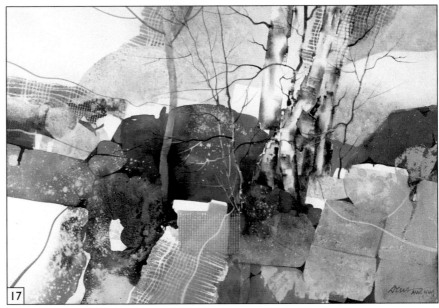

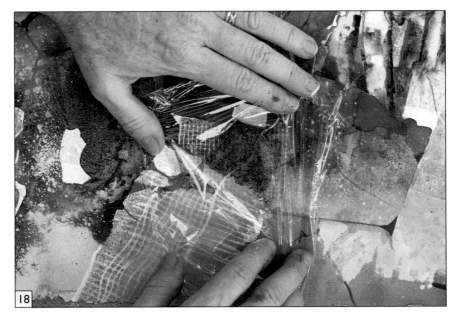

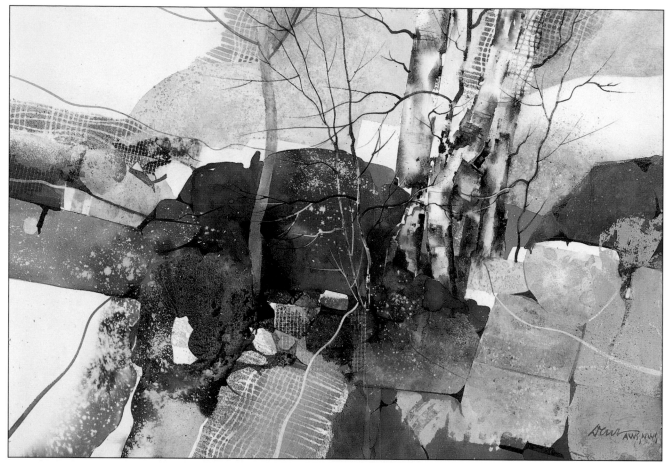

19 Finish

It looks so much better with the rock color adjustment, and the dark exit line is just right. The Mahogany lump is gone, and the painting is at last integrated. I'm satisfied.

BIRCH STAND WITH GRID
14¼" × 20¼" (36.2cm × 51.4cm)
Watercolor, acrylic and ink on BFK Rives
printmaking paper
Collection of Mr. and Mrs. Daniel McCarthy

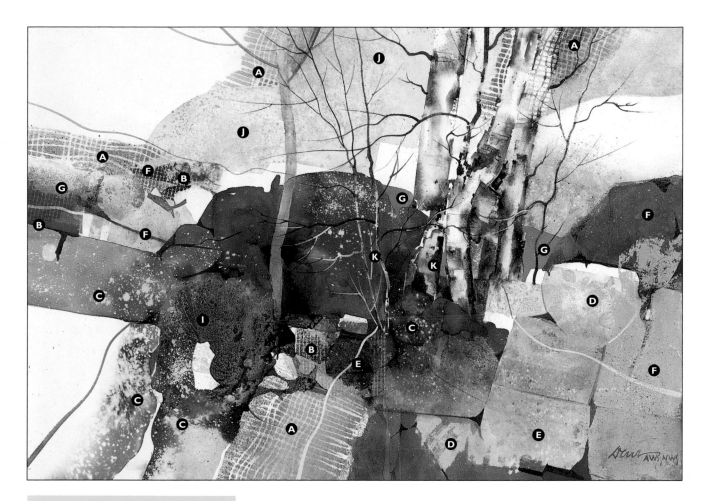

LEGEND

A Plastic mesh bag
B Drywall crack tape
C Bleach
D Waxed paper
E Saran Wrap
F Waxed paper transfer
G Sprayed paint
H My favorite paint mixture (Liqui-
 tex Phthalocyanine Blue, Burnt
 Sienna acrylic and gesso)
I Saran Wrap transfer
J Sponge painting
K Bleach lift

FINISH #2

Materials List

Winsor & Newton Water Colours:
- Alizarin Crimson
- Cerulean Blue
- Burnt Sienna
- Raw Sienna
- Ultramarine Blue

FW Drawing Ink
- Turquoise

Dr. Ph. Martin's:
- Antelope Drawing Ink
- Indigo Drawing Ink
- Orange Drawing Ink
- Mahogany Radiant Concentrated Watercolor (not lightfast)

Liquitex Acrylics:
- Phthalocyanine Blue
- Burnt Sienna
- Raw Sienna
- Ultramarine Blue

Brushes:
- 1-inch (25mm) flat
- 2-inch (51mm) Skyflow
- no. 4 round
- rigger

Texture Materials:
- Alcohol
- Diluted bleach
- Drywall crack tape
- Liquitex gesso
- Mouth atomizer

- Natural sponge
- Plastic mesh bag
- Saran Wrap
- Waxed paper

Additional Materials:
- Acetate
- Collage pieces
- Construction paper
- Gloss medium
- Masking tape
- Pencil
- Pueblo photo
- Ruler
- Saral transfer paper
- Scotch tape
- Fine-point permanent marker

1 Begin Again

This second start is as identical to the first as possible. I made a tracing of the first and transferred it to my support with Saral transfer paper. I use the same beginning colors and textures as the first start. This one I'll paint right side up. The great water mark in the Mahogany almost convinces me to make a seascape, but the square shapes strongly remind me of pueblo dwellings.

2 Use Acetate to Make a Plan

Looking at my photo, I draw an outline with a permanent marker on a sheet of translucent, matte finish acetate.

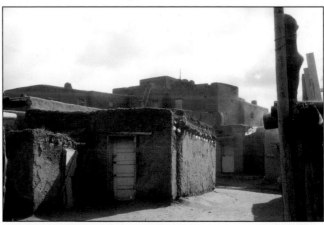

This is one of many photos my friend Eleanor gave me from her trip to New Mexico. It will be a perfect reference.

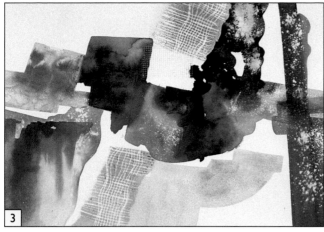

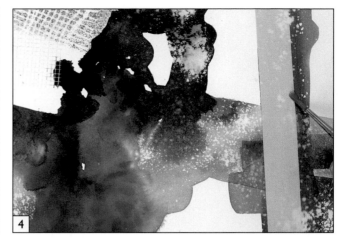

3 Bleach Spritz

Working upright, I wet the left side and let the paint flow down. My reference photo doesn't show a cliff, but I'm imagining there is one. I use Mahogany and Indigo ink on the left side and Mahogany, Turquoise and Antelope ink on the right. I used too much diluted bleach, so after texturing, I wipe the spritzed area with clear water to remove most of the bleach. I use a 1-inch (25mm) flat for the long Mahogany board, using a ruler's edge as a guide.

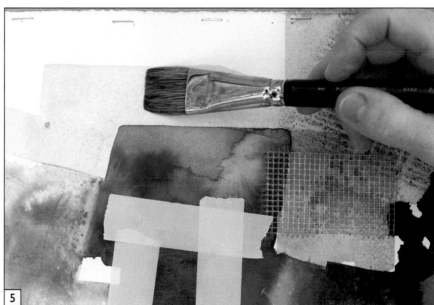

4 Making Decisions

I decide there's too much bleach and pink. I cover the long pole with masking tape and paint gloss medium on the edge so paint can't seep under it. I paint one edge with Liquitex Phthalocyanine Blue, Burnt Sienna acrylic and gesso, and the other with Raw Sienna acrylic and gesso. At the same time I tape a shape that will be a door.

5 Paint the Buildings

I paint the dwellings using the same mix of the curved neutral on the bottom: Winsor & Newton Burnt Sienna, Cerulean Blue and a little Alizarin Crimson watercolor.

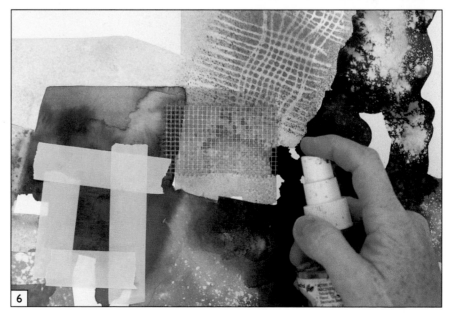

6 Alcohol Spritz

I use a concentrated mix of the neutral with a larger amount of Alizarin Crimson over the drywall crack tape and spritz alcohol for rocklike texture.

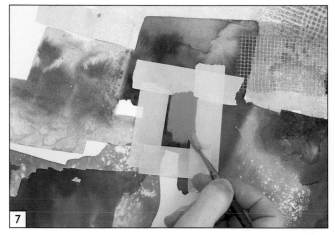

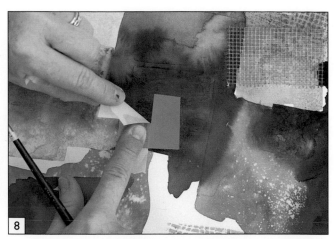

7 Paint
I paint the door with my favorite mixture. This mixture—Liquitex Phthalocyanine Blue, Burnt Sienna and gesso—can be made many different colors simply by adjusting the amount of each ingredient.

8 Peel the Tape
Peel slowly and carefully or you can rip the paper. Keep your hand on the tape and keep moving it down the tape, removing a small section at a time.

9 Overview
The angle is off on the buildings I added; they look blah. A lot of my angles are off on purpose, but since this is painted in such a traditional manner, it looks wrong. The pink pole is too dark and has too much bleach, and I don't like all that Raw Sienna wood to the right of the pole.

10 Have Fun
I decide to have fun and use collage. I hold and tape pieces from my collage box and think they'll look good. The sky is Liquitex Acrylic Ultramarine Blue and Burnt Sienna with a smidgen of gesso.

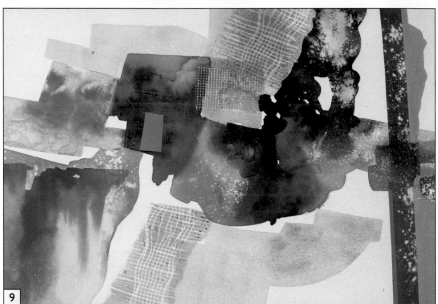

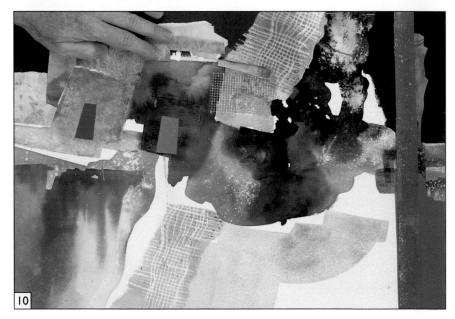

11 Glue and Sponge
I use Liquitex Gloss Medium to glue, and I sponge off any excess immediately. The blue that peeps through the sky area will become a window.

12 Modeling
With a rigger and Antelope ink I model the surface of the pueblo.

13 Overview
Shaping up—it's almost there. I love the turquoise line coming from the bag texture leading out as the rope around the pole. The drip on the right of the bottom center is a great drip. It really improved the design.

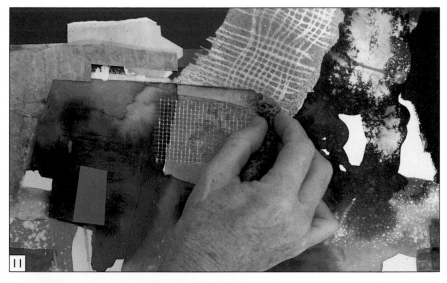

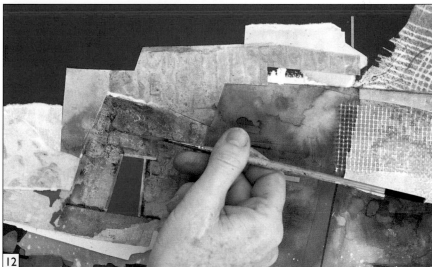

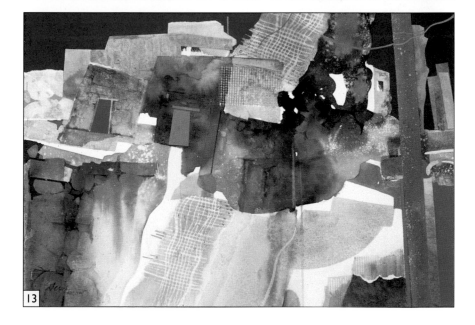

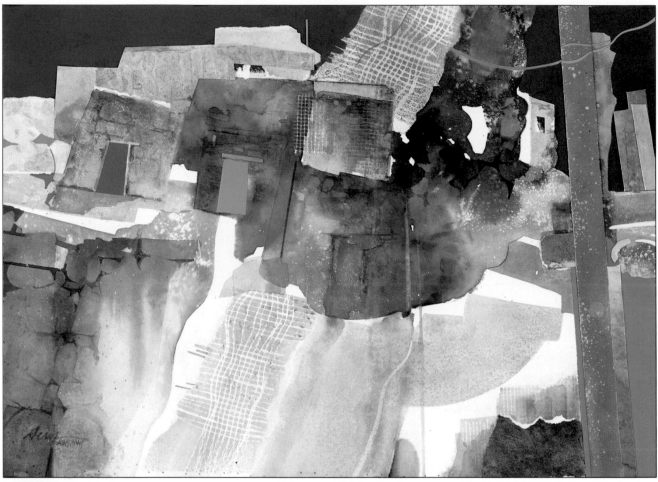

14 Finish

I think about adding a ladder, but decide the bag texture makes a nice one. I make the area in the bottom right corner marginally lighter along with the door and rock modeling to the left of the gold pueblo, top left. I retape the center mauve side of the mahogany pueblo and spray again for value change and add more modeling. I like it!

PUEBLO WITH BLUE, for Keemakoo
14¼″ × 20¼″ (36.2cm × 51.4cm)
Watercolor, acrylic and ink on BFK Rives printmaking paper
Collection of James and Allison Dews

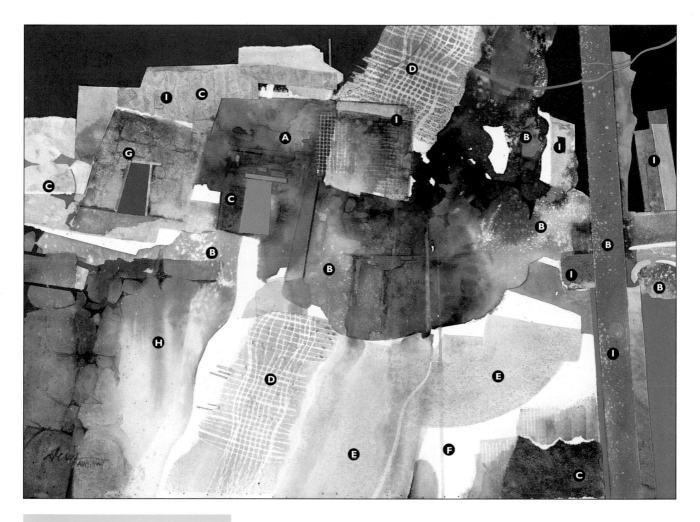

LEGEND

A Watermark

B Bleach texture

C Waxed paper texture

D Plastic mesh bag texture

E Alcohol spotting

F Drip

G Natural sponge texture

H Wet-in-wet upright position

I Collage pieces

FINISH #3

Materials List

Winsor & Newton Water Colours:

 Alizarin Crimson

 Cerulean Blue

 Burnt Sienna

 Raw Sienna

 Ultramarine Blue

FW Ink:

 Turquoise drawing

 Indigo acrylic

 Turquoise acrylic

 White acrylic

Dr. Ph. Martin's:

 Antelope Drawing Ink

 Indigo Drawing Ink

 Mahogany Radiant Concentrated
 Watercolor (not lightfast)

 Sepia Hydrus Watercolor

 Burnt Sienna Hydrus Watercolor

 Burnt Umber Hydrus Watercolor

 Mystery Brown (combination of
 leftover inks and watercolor)

Liquitex Acrylics:

 Bocour Dioxidine Purple

 Burnt Sienna

 Cadmium Red Extra Deep

 Deep Brilliant Red

 Hooker's Green Hue Permanent

 Phthalocyanine Blue

 Raw Sienna

 Ultramarine Blue

 Vivid Lime Green

 Pearl Cadmium Scarlet

Brushes:

 1-inch (25mm) flat

 2-inch (51mm) Skyflow

 no. 4 round

 rigger

 toothbrush

Texture Materials:

Alcohol

Diluted bleach

Drywall crack tape

Liquitex gesso

Mouth atomizer

Natural sponge

Plastic mesh bag

Rice paper

Saran Wrap

Waxed paper

Additional Materials:

 Construction paper

 Masking tape

 Pencil

 Photo of rocks taken in Corea,
 Maine

 Ruler

 Saral transfer paper

 Scotch tape

A Third Beginning

1 Once again I trace and paint as closely as possible with the same colors and textures. I want this painting to be more abstract than the other two. I think it would be nice to make it a vertical painting; however, I start horizontally. I look at my reference photos and decide to use the jetty.

Begin to Paint

2 I use the reference and paint in rock sections. I try to relate them to the neutral color curved shape and to the photo with Winsor & Newton Ultramarine Blue and Burnt Sienna watercolors. Unfortunately, I'm out of Antelope and have to use a mystery brown on the right—it's pretty yucky. I switch to Hydrus Sepia and Burnt Sienna for the center brown. Better, but no Antelope. I use Saran Wrap to press in texture, and it looks like roadkill. There was too much paint, and I move the excess that's still on the Saran Wrap to the left for a transfer. Indigo ink is painted over the drywall crack tape.

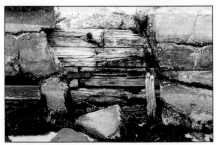

Jetty photo reference

116

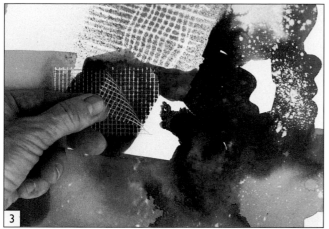

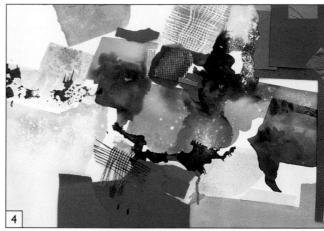

3 Remove Tape
The drywall crack tape is self-adhesive and works great. The paint only goes in the spaces of the tape, leaving a grid pattern.

4 Now I Need a Plan
Colored construction paper and the plastic mesh bag show me where I want to go. I definitely want to get away from the pinks and pastel shades for this version.

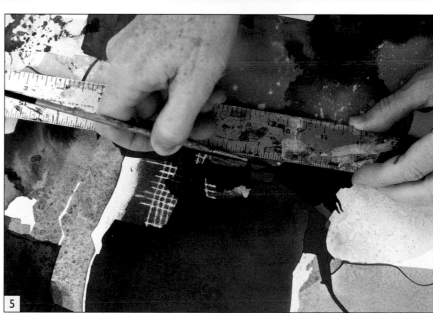

5 Ruler Line
I paint a red line using a rigger, ruler and mixture of Pearl Cadmium Scarlet, Liquitex Deep Brilliant Red and Cadmium Red Extra Deep acrylic paints.

6 Follow the Plan
I begin to paint, but I've turned the painting upside down. I use Winsor & Newton Ultramarine Blue and Burnt Sienna watercolors to paint areas that will relate to the rocks I've added. The upper right dark area was Liquitex Ultramarine Blue and Burnt Sienna acrylic, but it was too dark and I quickly brushed Bocour Dioxidine Purple over it.

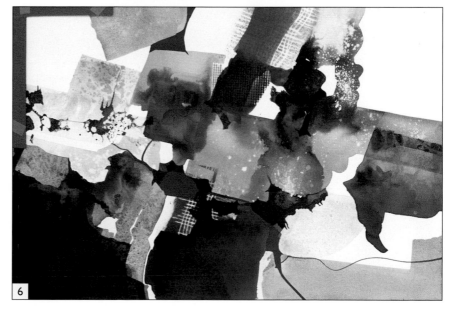

7 Spray
The painting needs a brightener. I use my new atomizer and spray FW Turquoise Acrylic Ink. An added plus to this new atomizer is that with the acrylic spray I can direct my spray fairly accurately without masking.

8 Overview
I finally have more Antelope ink and repaint the browns and cover the gray rock in the upper left corner with Antelope and Mahogany, then spatter with Raw Sienna acrylic and gesso. I use tape and medium to spatter. I think I need more Mahogany—the spatter covered a lot of it. I mix Antelope and Mahogany and pour the mixture over an open-weave rice paper (bottom right of center).

9 Change Direction
I really like this painting in both directions, but I'll finish it as a vertical. I make a paper towel mask and spray with my mouth atomizer and FW White Acrylic. I'm making a wave to go with my rocks. The white certainly adds some life! I immediately spritz with alcohol and manipulate the wave with a natural sponge.

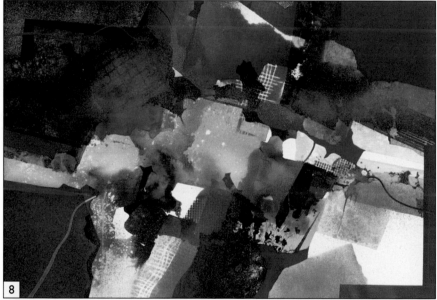

10 Overview of Wave
The sprayed wave adds a needed white.

11 Overview of Painting
It looks to me as though I have too many small shapes and should consider cutting the painting in half. I am longing to go right in there and change colors and shapes, but I want to keep the core shapes so the beginning start is still evident. If I were painting for myself, that's what I'd do. Perhaps I should here. A start only has to get you going. I decide it would be beneficial for you to see me keep some of the core shapes.

The wave is modeled with FW Indigo and Turquoise Drawing Ink. I move white water (gesso) down and through the painting. I brush gloss medium over areas that get spritzed with alcohol. The midsection is brushed and the bottom is sprayed with additional FW Indigo and Turquoise Acrylic. The central blue section of rocks is inspired by a favorite photo I took in Corea, Maine. Pablo Picasso said, "There is no abstract art. You must always start with something."

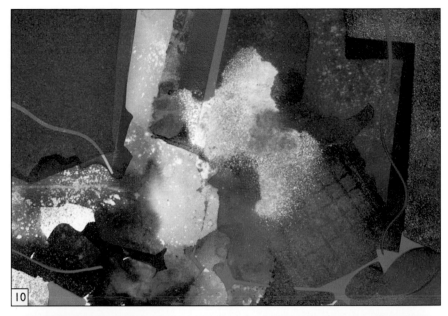

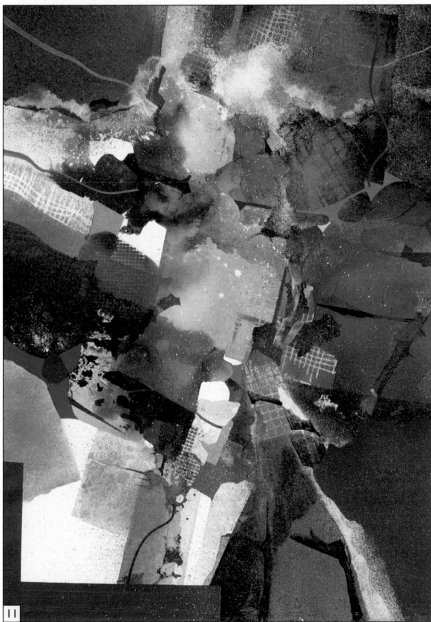

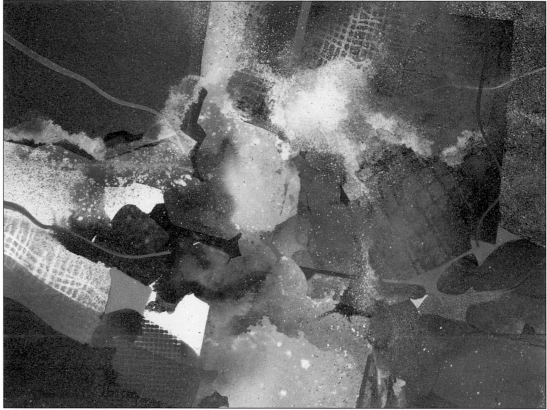

12A **Cropped Half**
I had to do it. I now have two paintings, but I need to make a few adjustments before each painting can stand alone as a whole.

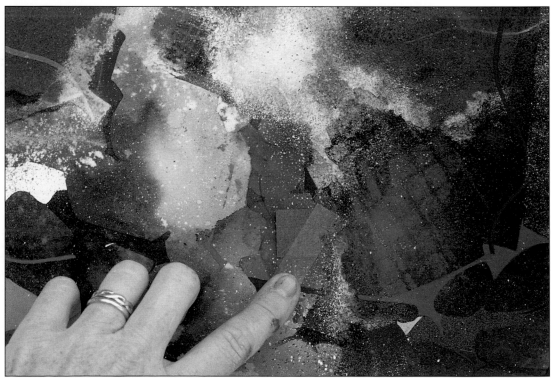

13A **Construction Paper Plan**
This was to be part of my homage series to Hans Hofmann and Richard Diebenkorn, so I test squares and lines with construction paper (see page 122 for the finished painting).

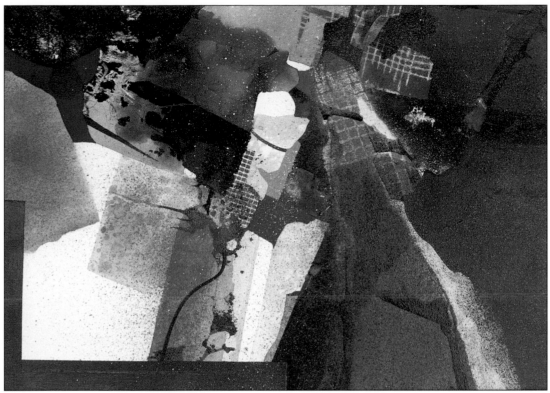

12B Study Cropped Version

This cropped section will make a good rock study. I need to add more white and red to pull it all together. I think it's obvious that I needed to crop this painting (see page 124 for the finished painting).

13B Construction Paper Study

I tape white paper in different locations to see where the best placement will be. There is always more than one way to finish. If you do a series, you can try them all.

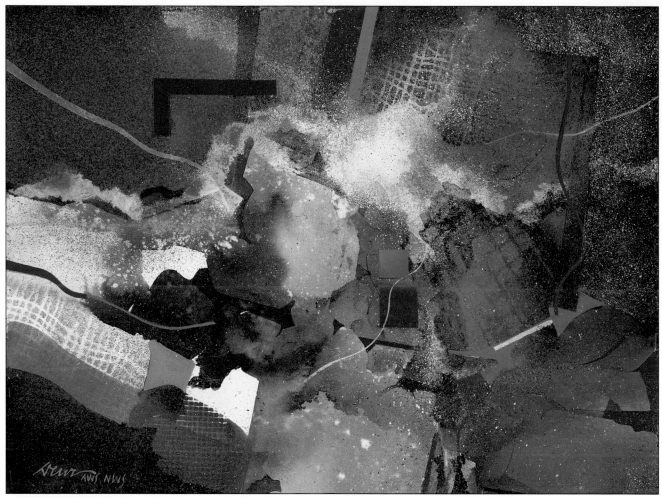

14A Finish A

I think the line fills the upper left space well, and the squares of color add the right balance. The line is Deep Brilliant Red, Cadmium Red Extra Deep, Pearl Artist's Acrylic Cadmium Scarlet and Phthalocyanine Blue. The square is Vivid Lime Green, Hooker's Green Hue and Phthalocyanine Blue. I like this cropped version and think it's a good addition to my continuing series. Even though the painting was made smaller, I think it reads big. I like the planes and the movement of the water in and out of them. I can feel the water and mist enveloping the rocks.

A WALK THROUGH MONTAUK WITH
RICHARD AND HANS 4, for Baby and Bluey
10¾" × 14¼" (27.3cm × 36.2cm)
Watercolor, acrylic and ink on BFK Rives
printmaking paper
Collection of Kumiko and Joseph Dews

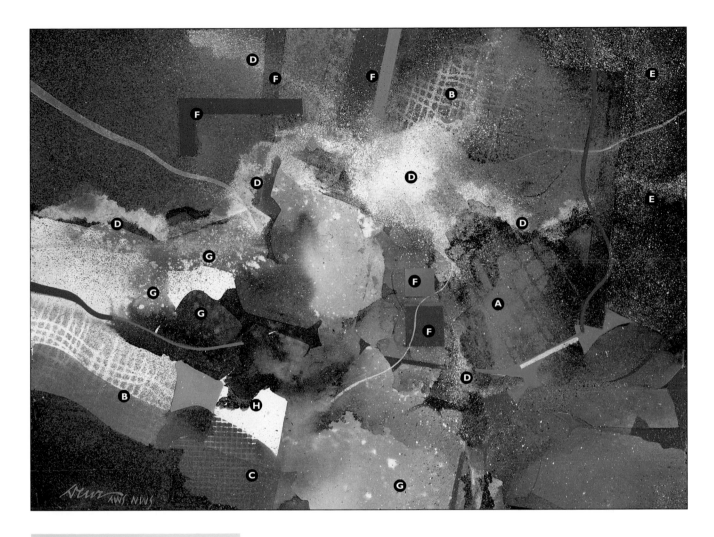

LEGEND

A Large grid spray (hooked rug
 support)

B Plastic mesh bag spray

C Drywall crack tape

D Spray

E Spatter

F Tape and paint

G Bleach texture

H Saran Wrap texture

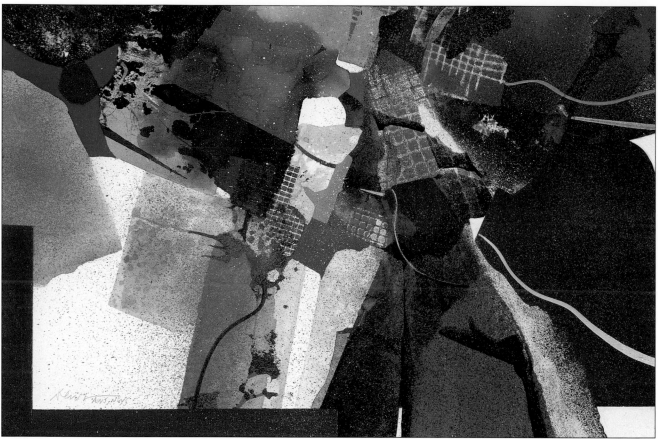

14B Finish B

I use gesso to negatively paint rock shapes and continue the red line across the painting in white. I use the white gesso to model the rocks in the form of lines. More red is added to the central blue channel crevice. A bit more spray through the drywall crack tape is added to the left of center for placement of texture and color. The pink from the left is brought over to the right in a line. Additional lines are added in white for color movement, direction and definition. I think this is a good rock study, and I had no thought when I started that this is what I would end up with. It's more of a challenge; I hate to be bored, and it's nice to be surprised.

ROCK STUDY 90
9¼″×14″ (23.5cm×35.6cm)
Watercolor, acrylic and ink on BFK Rives
printmaking paper

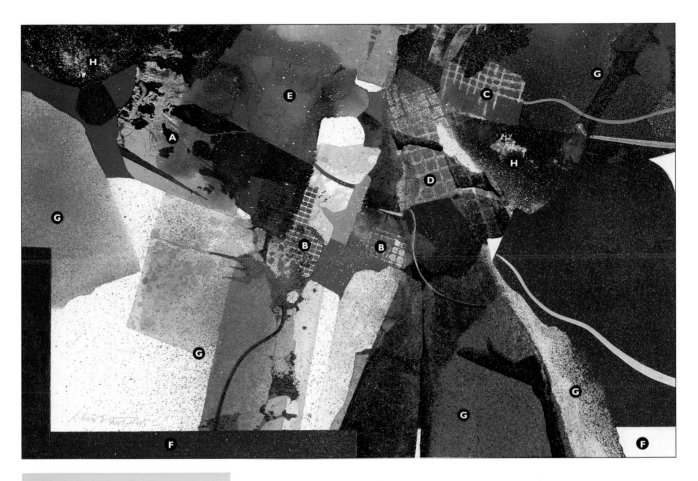

Concluding Thoughts

I hope my book inspires you, stretches your imagination and takes away your fears of painting. If you have the desire and work hard, I truly feel great things are possible for you. For me the journey is the best part. Try to hold the initial joy and excitement you feel as you make your own discoveries. Have fun and enjoy the experience of painting.

ACADIA REMEMBERED
27″×27″ (68.6cm×68.6cm)
Watercolor, acrylic and ink on BFK Rives
printmaking paper
Awarded The High Winds Medal, 128th Exhibition,
American Watercolor Society

◄ DEEP WOODS
21″×29½″ (53.3cm×74.9cm)
Watercolor and collage on BFK Rives
printmaking paper

Index